D1632873

THE GREAT WESTERN RAILWAY

— VOLUME 5 —

SHREWSBURY TO PWLLHELI

Stanley C. Jenkins & Martin Loader

AMBERLEY

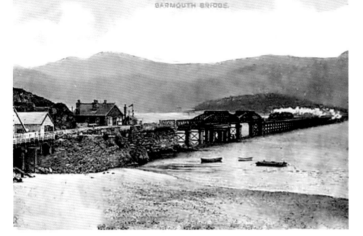

Barmouth Bridge

An Edwardian colour-tinted postcard showing Barmouth Bridge – the principal engineering feature on the Cambrian Coast line.

ACKNOWLEDGEMENTS

Thanks are due to Mike Marr for the use of the photographs on pages 68, 69 and 72. Other images were obtained from the Lens of Sutton Collection, and from the authors' own collections.

A Note on Closure Dates and Distances

British Railways' closure announcements referred to the first day upon which services would no longer run, which would normally have been a Monday. The final day of operation would usually have been the preceding Saturday or Sunday; in other words, the closures concerned would take place on a Saturday or Sunday, and with effect from the following Monday. The datum point for the calculation of distances on the Cambrian route was originally Whitchurch but, following the closure of the line between Whitchurch and Buttington Junction, Shrewsbury has become the 'starting point' for journeys over the lines to Aberystwyth and Pwllheli.

First published 2015

Amberley Publishing
The Hill, Stroud, Gloucestershire, GL5 4EP
www.amberley-books.com

Copyright © Stanley C. Jenkins and Martin Loader, 2015

The right of Stanley C. Jenkins and Martin Loader to be identified as the Authors of this work has been asserted in accordance with the Copyrights, Designs and Patents Act 1988.

ISBN 978 1 4456 4286 4 (print)
ISBN 978 1 4456 4299 4 (ebook)

British Library Cataloguing in Publication Data.
A catalogue record for this book is available from the British Library.

Typesetting by Amberley Publishing.
Printed in Great Britain.

HISTORICAL INTRODUCTION

The Welsh border area saw much promotional activity during the 'Railway Mania' years of the 1840s. One of the schemes floated at that time was the North Wales Mineral Railway, which sought powers for the construction of a line between Chester and the Wrexham and Ruabon coalfields. The North Wales Mineral Railway obtained its Act of Incorporation on 6 August 1844, while in the following year, a group of North Wales Mineral Railway supporters launched the Shrewsbury, Oswestry & Chester Junction Railway, with the aim of extending the North Wales Mineral line southwards to Shrewsbury. The Shrewsbury, Oswestry & Chester Junction Bill received the Royal Assent on 30 June 1845, and in 1846 the Shrewsbury, Oswestry & Chester Junction Railway joined forces with the parent North Wales Mineral Co. to form the Shrewsbury & Chester Railway. The line was opened between Saltney Junction (Chester) and Ruabon on 4 November 1846, and the S&CR route was completed throughout to Shrewsbury on 14 October 1848.

There was, as yet, no direct link to Oswestry, although Oswestry featured in a variety of schemes which, if completed, would have provided a line between the Midlands and South Wales. In 1846, for example, the Shropshire Union Railways & Canal Co. projected a cross-country route from Crewe to Newtown via Whitchurch, Ellesmere, Oswestry and Welshpool. At Newtown, this line would have joined a proposed line to Aberystwyth, while at Whitchurch a short branch would diverge southwards to reach Wem. In connection with this scheme, the Shrewsbury, Oswestry & Chester Junction Railway had itself obtained powers for a 2 mile 31 chain branch from Gobowen to Crickheath, which was completed as far as

Oswestry under Shrewsbury & Chester auspices and ceremonially opened on 23 December 1848, with public services commencing on 1 January 1849.

THE OSWESTRY & NEWTOWN RAILWAY

This was not, by any means, the final railway development at Oswestry, and it was still hoped that the Gobowen to Oswestry branch would become part of a much longer route through mid-Wales to Aberystwyth, or even to Milford Haven. If built in its entirety, such a line would carry heavy traffic in manufactured goods destined for export to North America, while, at the same time, any line from South Wales to the industrial areas of England could be expected to carry a profitable traffic in Welsh coal. Not surprisingly, the Great Western and London & North Western companies were actively promoting lines in the area. In 1855, for example, the L&NWR sought powers for a railway between Shrewsbury, Oswestry and Newtown, but this project was abandoned following an agreement between the GWR and North Western companies.

A year later, in 1854, the Oswestry & Newtown Railway was promoted. This new scheme was the brainchild of George Hammond Whalley (1813–78) of Plas Madog, near Ruabon, the High Sheriff of Caernarvonshire, who had recently been elected as the Liberal MP for Peterborough. G. H. Whalley was a philanthropist who had made considerable efforts to establish fisheries on the west coast of Ireland during the famine years of the 1840s. As far as Welsh railways were concerned, he was a key figure, being an active promoter in numerous local schemes. He was also something of an eccentric and,

despite his supposed 'Liberal' credentials, he was a vociferous anti-Catholic, who seems to have harboured an irrational fear that the Pope was trying to seize control of the railways, the police and the Royal Artillery!

With future extensions being planned towards Carmarthen and Milford Haven, it was hoped that the Oswestry & Newtown Railway would 'form a direct route for New York passenger traffic'. These hopes were, perhaps, somewhat over-optimistic, but the Oswestry & Newtown line was nevertheless welcomed as a useful link in the local railway system. Before proceeding with their scheme, the O&NR promoters first had to seek Parliamentary consent, and in November 1854 they gave notice that an application would be made to Parliament in the ensuing session for powers to construct a railway 'commencing near the new Parish Church in the Parish of Newtown, in the County of Montgomery, in a certain field there, by a junction with the intended Llanidloes & Newtown Railway', and terminating 'by a junction with the Oswestry branch of the Shrewsbury & Chester Railway'.

The Oswestry & Newtown Bill received the Royal Assent on 26 June 1855, and the first section of the line was opened between Oswestry and Pool Quay on 1 May 1860. The route was extended westwards to Welshpool on 14 August 1860, and, finally, on 10 June 1861 the Oswestry & Newtown Railway was completed throughout to Newtown, where connection was made with the Llanidloes & Newtown Railway, which had been opened for the carriage of passengers on 31 August 1859. At its northern end, the Oswestry & Newtown line joined the GWR branch from Gobowen, but this arrangement was somewhat unsatisfactory insofar as the Oswestry & Newtown Railway and its allies were entirely dependent on the GWR for access to and from the populous areas of England.

THE LLANIDLOES & NEWTOWN RAILWAY

The Llanidloes & Newtown Railway was slightly older than the Oswestry & Newtown line, having been formed in 1852, largely through the efforts of George Whalley. In November 1852, the supporters of the scheme gave notice that they intended to seek Parliamentary consent for the construction of a railway commencing 'in a pasture field called Eryfongam, situated in the township of Cilmachallt, otherwise Cilfachallt, in the Parish of Llanidloes in the County of Montgomery', and terminating in 'a certain field situated at the back, or on the south side of, and adjoining to the dwelling house and premises the property of, or reputed to belong to, and in the occupation of George Green, in the Parish of Newtown in the said County of Montgomery'.

The Llanidloes & Newtown Railway Bill received the Royal Assent on 4 August 1853. Having obtained their Act of Incorporation, the promoters were able to proceed with their scheme. The first sod was cut by the chairman, George Whalley, 'in the presence of a large number of spectators' at Llanidloes on 3 October 1855. Construction was soon in full swing, the contractor being David Davies (1818–1900) of Llandinam, while the engineer was Mr Rice Hopkins (later replaced by George Coneybeare). David Davies, the son of a local sawyer, was an archetypal 'self-made man', who would ultimately be instrumental in the provision of railways throughout mid-Wales – many of his promotional activities being in conjunction with Thomas Savin (with whom he later fell out).

In May 1857, the *North Wales Chronicle* reported that the works were 'rapidly progressing', and the rails would 'shortly be laid'. The bridges were being erected and the earthworks were 'so far advanced as to ensure the opening of the line in October next'. In the meantime, a problem had arisen insofar as one of the main promoters, Mr Lefeaux, had agreed to take up one sixth of the capital on condition that the company's entire capital of £60,000 was fully subscribed. However,

only £30,000 was actually subscribed, and George Whalley therefore assumed responsibility for Mr Lefeaux's shares.

In 1858, it was revealed that the company was suffering 'financial embarrassments', but in the following year David Davies and his business partner Thomas Savin offered to complete the line under an arrangement whereby they would be paid in the railway's unissued shares and debentures. The contractors also agreed to lease the line for a period of ten years, during which time they would pay the shareholders a guaranteed dividend rising from 4 per cent after the opening of the first section of line, to 10 per cent after the sixth year. Having agreed to these terms, the directors were able to proceed with their scheme and the line was opened for goods traffic on 30 April 1859.

Having passed its Board of Trade inspection in June 1859, the line from Newtown to Llanidloes was opened on 31 August 1859 and, as usual in those days, opening day was treated as a public holiday in Llanidloes and the surrounding district. The town was decorated with flags, bunting and arches of evergreen, while the official 'first train' from Newtown was welcomed by cheering crowds and the Plasmadoc brass band, which played *See The Conquering Hero Comes* as the inaugural special entered the station. The newly opened railway was, at first, an entirely self-contained line with no connections to the rest of the system, but this unsatisfactory situation was rectified on 10 June 1861, when the Oswestry & Newtown Railway reached Newtown.

THE NEWTOWN & MACHYNLLETH RAILWAY

The Newtown & Machynlleth Railway was formed during the mid-1850s by local landowners including Sir Watkin Williams Wynn (1820–85) and George Henry Vane Tempest, the 2nd Earl Vane, who were keen to bring the benefits of rail communication to hitherto-remote towns and villages such as Carno, Llanbrynmair and Machynlleth. The

scheme was sanctioned by Parliament on 27 July 1857, although the first sod was not cut until the following year. After several delays, a contract for construction of the 23 mile line was awarded to David Davies and Thomas Savin for £130,000, and in March 1857 it was reported that work had 'commenced near Caersws with the object of completing as soon as possible the first nine miles to Talerddig'. The first 3 miles were said to be 'nearly complete' by March 1861, while work was under way on 'the great rock cutting at Talerddig', which was expected to yield 'sufficient stone of the highest quality for the whole of the works'.

The half-yearly meeting held in Machynlleth in February 1862 was an optimistic gathering. The directors were able to report that the rails had been laid over 'nearly 20 miles of the line', and it was anticipated that the entire route, around 23 miles in length, would be 'ready for opening in good time for next year's summer traffic'. The chairman, in moving the adoption of the report, announced that he had that very morning travelled over 16 miles of the railway in order to attend the meeting, and he praised the contractor Mr Davies, 'for the energy with which he had carried on the works, and the astonishing progress which had been made during the previous half-year'.

The Newtown & Machynlleth line was virtually complete by the end of 1862, and having passed its Board of Trade inspection the railway was opened on Saturday 3 January 1863. The opening day celebrations were described in great detail by contemporary newspapers such as the *North Wales Chronicle*, which reported that Machynlleth was adorned with decorative archways displaying appropriate mottoes, while the first train from Machynlleth to Newtown, consisting of twenty-two coaches drawn by two locomotives, left the station carrying around 1,500 first day travellers. The inaugural train returned to Machynlleth at 12.30, by which time

it had been strengthened to no less than twenty-six coaches packed with over 2,000 people. Speeches of welcome having been made at the station, the directors and their VIP guests processed to the town hall, where the customary 'cold collation' was awaiting them. Meanwhile, the Unicorn Arms and other public houses were also doing good business, while in the evening fireworks were let off in the streets to conclude the celebrations.

Regular public services commenced on Monday 5 January 1863. The newly opened railway left the Llanidloes & Newtown line at Moat Lane Junction, near Caersws, and this had the incidental effect of relegating the 7¾ mile section of line between Moat Lane and Llanidloes to branch line status. However, this situation was transformed by the opening of the Mid Wales Railway on 1 September 1864, which turned the Llanidloes 'branch' into part of a sinuous through route to the industrial areas of South Wales.

THE OSWESTRY, ELLESMERE & WHITCHURCH RAILWAY

In the meantime, a further company known as 'The Oswestry, Ellesmere & Whitchurch Railway' had been formed to link the Oswestry & Newtown Railway with the London & North Western Railway at Whitchurch. If successfully completed, the proposed line would break the monopoly of the Great Western Railway at Oswestry, while at the same time, the suggested rail link would provide much-needed transport facilities for the inhabitants of Ellesmere, Bettisfield and other local communities. The scheme was put before the public at a meeting held in Ellesmere in 1857 and a provisional committee was soon working to implement the project. The proposed line to Whitchurch was strongly supported in Ellesmere, and in December 1860 a 'memorial' was signed by local ratepayers, who were 'in favour of the proposed Oswestry, Ellesmere & Whitchurch Railway' and

opposed 'to any Branch or other Line proposed by the Great Western Company to Ellesmere'.

A Bill was lodged for consideration in the 1861 session, and having successfully passed all stages of the complex Parliamentary process, The Oswestry, Ellesmere & Whitchurch Railway Act received the Royal Assent on 1 August 1861. The authorised line would be 18 miles long, and to pay for its construction the promoters were authorised to raise the sum of £150,000 in £10 shares, with an additional £50,000 by loan. A period of three years was allowed for the purchase of land, and five years for completion of the works. Perversely, Parliament insisted that the eastern section from Whitchurch to Ellesmere should be built first, the idea being that the Great Western Railway might proceed with a rival scheme for construction of a line to Ellesmere. In the event of such a line being built, the two companies would have to come to an agreement concerning running powers over each section.

In engineering terms, the authorised route was a relatively easy proposition. Extending north-eastwards from Oswestry, the line would cross a tract of generally level terrain. Bridges would be necessary in order to carry the Oswestry, Ellesmere & Whitchurch line across the Shrewsbury & Chester main line and the Holyhead Road in the vicinity of Whittington, but otherwise the principal engineering difficulties would be encountered between Bettisfield and Fenn's Bank, where the railway would cross a treacherous peat bog with an estimated depth of around 12 feet.

Work on the Whitchurch to Ellesmere line commenced in August 1861, the ceremonial 'first sod' being cut in a field near Ellesmere Workhouse. The first incision was made with the aid of a specially decorated spade and barrow, and after the sod cutting had taken place the official party attended a grand banquet at which numerous speeches

were made. Despite problems with certain landowners, who supported a rival GWR scheme for a line to Ellesmere, construction was under way by the beginning of 1862 - the line being laid across Fenn's Moss with the aid of deep drains, rafts of faggots and larch poles.

Meanwhile, there were problems with the GWR which, in 1862, sought Parliamentary consent for a whole series of lines in the Oswestry and Ellesmere area. The Great Western proposals envisaged a line commencing at Oswestry by an end-on junction with the existing branch from Gobowen, and terminating at a place known as 'Mile End' on the nearby Shrewsbury & Chester main line. Here, the suggested line would join the Shrewsbury & Chester route, while a further line would extend north-eastwards to Ellesmere. Parliament seemed, at one stage, to be in favour of the GWR line, though in the event the scheme was thrown out, and the OE&W proprietors were able to proceed with their original project.

In a second sod-cutting ceremony, the first turf of the Ellesmere to Oswestry line was turned near the Oswestry & Newtown station in Oswestry on 4 September 1862. Watched by a large crowd, Miss Lloyd, the daughter of the Mayor of Oswestry, and Miss Kinchant of Park Hall, delicately wielded the ceremonial spade, and the official party then progressed through the town to the Wynnstay Arms, where a banquet was served on the bowling green. The festivities continued with a grand fête and a meal for the poorer inhabitants of the town. The Whitchurch to Ellesmere section was ready for opening by the spring of 1863, the completion of this first portion of the line being marked by the running of a special train on 20 April 1863 – the first passengers being a company of Rifle Volunteers, while the inaugural special was hauled by the Oswestry & Newtown Railway locomotives *Montgomery* and *Hero*. The new line was opened just a few days later, on 4 May 1863.

The final section, of a little over seven miles, was not yet ready for opening, and Ellesmere remained the terminus of a branch from Whitchurch for just over one year. Meanwhile, as work continued apace on the Ellesmere to Oswestry line, the shifting sands of company politics were about to change the entire pattern of railway development in mid-Wales. It was decided that the Oswestry & Newtown, Newtown & Machynlleth, Llanidloes & Newtown and Oswestry, Ellesmere & Whitchurch companies would be amalgamated to form a much larger company known as 'The Cambrian Railways', an Act for this purpose being obtained on 25 July 1864. Just two days later, on 27 July 1864, the Ellesmere to Oswestry line was opened to traffic, and the newly created Cambrian Railways Co. thereby gained a direct link to England which was entirely independent of the rival Great Western system.

THE CAMBRIAN COAST LINE

Attention now shifts to the western parts of the Cambrian system, where efforts were being made to construct a railway along the Welsh coast from Aberystwyth to Porthdinlleyn on the Lleyn Peninsula – a company known as 'The Aberystwith [sic] & Welsh Coast Railway' having been incorporated by an Act of Parliament on 22 July 1861, with powers for the construction of railways from Aberystwyth 'to various places in the counties of Cardigan, Montgomery, Merioneth and Carnarvon'. The scheme included a link to the Newtown & Machynlleth Railway, which would extend north-eastwards from Ynyslas to Machynlleth.

In engineering terms, the Aberystwyth & Welsh Coast line presented many difficulties – the greatest problems being at Aberdovey, where it was envisaged that the railway would cross the Dovey Estuary, and between Barmouth and Morfa Mawddach, where the authorised line would be carried across the tidal Mawddach Estuary which was, at

that time, navigable as far upstream as Dolgellau. It soon became apparent that the planned Dovey Bridge was impracticable, the depth of the sediment being so great that solid rock could not be found. Therefore, it was decided that the authorised line would be deviated. Having obtained Parliamentary consent in 1865, the company began construction of an alternative line along the north side of the estuary between Aberdovey and what became Dovey Junction – thereby adding 12 miles to the route between Aberystwyth and Pwllheli. This change of plan meant that the Aberystwyth & Welsh Coast line became a V-shaped system with two divergent branches, one of which would run south-westwards from Dovey Junction to Aberystwyth, while the other would extend northwards along the coast towards Pwllheli.

Pending completion of the deviation line, the Aberystwyth & Welsh Coast route was opened between Aberdovey and Llwyngwril on 24 October 1863. The A&WCR route was, thereafter, opened in stages, the section from Llwyngwril to Penmaenpool, near Dolgellau, being opened on 3 July 1865. In the meantime, work was proceeding apace on the Aberystwyth line, which was opened between Machynlleth and Borth on 1 July 1863 and completed throughout to Aberystwyth on 23 June 1864.

The Barmouth Bridge was, as yet, unfinished, but Henry Coneybeare, the company's engineer, had prepared plans for a wooden trestle viaduct of 113 spans, supported by 500 timber piles. The structure included a moving section, originally a drawbridge, at the north end to permit the passage of shipping. The work was completed by July 1866, the first locomotive to cross the bridge being the 2-4-0 *Mazeppa*. Passengers were carried across the bridge from 3 June 1867, although at first all services were worked by horses. In the meantime, the Aberystwyth & Welsh Coast Railway had been amalgamated with the Cambrian Railways under the provisions of an Act obtained on 5 July 1865, the merger becoming effective on 5 August 1866. As a result of this amalgamation, the unfinished portions of the A&WCR route were completed under Cambrian auspices – the line was brought into use between Dovey Junction and Aberdovey on 14 August 1867, while the final section between Barmouth and Pwllheli section was opened on 10 October 1867.

THE SHREWSBURY & WELSHPOOL RAILWAY

The Oswestry, Ellesmere & Whitchurch route was, from its inception, regarded as an integral part of the Cambrian main line, though in the longer term its importance was compromised by the existence of the Shrewsbury & Welshpool Railway, which had been formed in the 1850s with the aim of constructing a direct link between the GWR and L&NWR systems at Shrewsbury and the Oswestry & Newtown route at Buttington, a distance of 21 miles.

The Shrewsbury & Welshpool Railway was incorporated by Act of Parliament on 29 July 1856, with powers for the construction of a 16¼-mile line commencing near Shrewsbury General station and terminating by a junction with the Oswestry & Newtown Railway at Welshpool. There was, in addition, to be a 6½-mile branch line to Minsterley, while the authorised capital was £150,000 in shares, with a further £50,000 by loan.

On 23 July 1858, the company obtained a further Act, allowing an extension of two years for completion of the works, while a third Act passed on 18 May 1860 authorised a further extension of time, together with minor deviations of the route. In the interim, the directors had entered into a contract with Alexander Thomas Gordon who undertook to purchase the land and construct the railway, paying all incidental expenses until the railway was opened, after which he would maintain the line for a period of one year. The Minsterley Branch was

opened on 14 February 1861, and the main line was completed on 27 January 1862.

The Shrewsbury & Welshpool Railway was acquired jointly be the Great Western and North Western companies in 1865, and both companies were thereby enabled to run through services to and from Aberystwyth and Pwllheli, which avoided the more circuitous Cambrian route via Ellesmere and Oswestry. The Whitchurch to Oswestry line was, on the other hand, well-placed in relation to traffic from Manchester and other populous cities in the north-western England, and it carried a considerable amount of through passenger and freight traffic to and from the L&NWR system.

SUBSEQUENT DEVELOPMENTS

Tourist traffic was important from an early date, and in the Victorian period the Cambrian advertised summer tourist tickets for first, second and third class travellers. These were available for two calendar months and were issued from 1 May to 31 October 'at all the principal stations in England' to Aberystwyth, Pwllheli, Towyn, Barmouth and other destinations on the Cambrian system. Arrangements were made in the summer months for visitors to travel through to the Ffestiniog and other Welsh narrow gauge railways, while horse-drawn vehicles were used to convey rail travellers to various places of interest in the vicinity of the Cambrian line.

There were, in addition to these facilities, a range of cheap excursion tickets from London, Birmingham, Liverpool, Manchester and other major cities, together with useful through services between inland areas and the Cambrian coast. In 1885, for example, the Cambrian advertised 'A Special Service of Express Trains ... daily during the season in connection with Fast Trains on the London & North Western and other Railways, with through carriages between ... Manchester (London Road) and Aberystwyth via Crewe, Ellesmere and Welshpool'. Similar services were provided to and from Liverpool Lime Street, and these were also routed via Ellesmere and Oswestry.

At the end of the Victorian period there were five through workings in each direction between Whitchurch, Oswestry and Aberystwyth. One of these services, the 12.20 p.m. from Whitchurch, covered the 95¾ mile journey in 205 minutes, with intermediate stops at Oswestry, Welshpool, Newtown, Moat Lane Junction, Glandovery Junction and Borth. The overall time from Manchester to Aberystwyth by this service was four hours.

In 1922, the Cambrian system was amalgamated with the Great Western Railway under the provisions of the Railways Act 1921, and in the next few years the Cambrian became very much a part of the much larger GWR system. The Great Western did much to publicise the many holiday destinations served by the Cambrian, with the result that resorts such as Aberystwyth, Barmouth and Pwllheli became very popular throughout the 1930s, when prestigious through services such as 'The Cambrian Coast Express' carried many thousands of happy holidaymakers down the winding single line. The end of the Second World War was followed, on 1 January 1948, by the nationalisation of the 'Big Four' railway companies. Thereafter, the Cambrian route became part of the Western Region of British Railways, though this change of ownership had little effect on the day-to-day life of the line – which continued to operate very much as it had done during the Great Western era.

The Cambrian system continued to serve the public during the 1950s and early 1960s but, like other rural lines, its passenger traffic declined as local travellers turned to buses or private road transport in increasing numbers. Under these circumstances, closures became inevitable – indeed, many of the smaller branch lines between

Whitchurch, Aberystwyth and Pwllheli had been closed during the 1930s. The Cambrian route was transferred to the London Midland Region in 1963, by which time major changes were in progress; branch lines and wayside stations were being ruthlessly closed, while diesel locomotives were about to replace steam engines as the primary source of motive power on Britain's railways.

The government of the day was no longer interested in maintaining the nationalised railway system in anything like its entirety, and, at a time when huge amounts of taxpayers' money was being expended on grandiose motorway building schemes, Transport Minister Earnest Marples embarked upon a deliberate and systematic policy of railway closure and retraction. In 1963, the publication of a report by Dr Richard Beeching entitled *The Reshaping of British Railways* recommended the withdrawal of passenger services from a further 5,000 miles of line and the closure of 2,363 stations. One of the routes to be deleted under the 'Beeching Axe' was the Whitchurch to Welshpool section of the Cambrian line, which was condemned as 'uneconomic' under the very rigid criteria adopted by the Beeching Report.

In a sense, this modest piece of rationalisation was logical in that, for many years, much of the long distance traffic on the Cambrian section had been routed via Shrewsbury and the former GWR–L&NWR joint line to Buttington. Despite local opposition, the closure went ahead as planned, the passenger service between Whitchurch and Welshpool being withdrawn with effect from Monday 18 January 1964. Having survived the 'Beeching Years', the Cambrian main line was itself threatened with closure during the 1970s, but the line now has a secure place in the national railway system; its train services are at present operated by Arriva Trains Wales, while a modernised Radio Electronic Token Block (RETB) signalling system has been in use on the line since 1988.

LOCOMOTIVES & ROLLING STOCK

The Cambrian Railways system was worked by a small fleet of (mainly) Sharp Stewart locomotives. Main line passenger services were normally hauled by 4-4-0s such as the 'Beaconsfield' class and the visually similar '61' class engines. The '61' class 4-4-0s were built between 1893 and 1904, and they survived on their native system until 1929–31, the last one in service was No. 83, which was withdrawn in 1931 (as GWR No. 1110). Freight services were worked by the well-known Cambrian Sharp Stewart 'Queen' class, and other 0-6-0s. The Cambrian had twenty-three 'Sharpies', several of which had been acquired from the Oswestry & Newtown Railway or other constituent companies. In 1903, the Cambrian introduced two new classes: the '94' class 4-4-0s being intended for use on passenger services, while the '89' class 0-6-0s were designed for goods work; both types had Belpaire boilers.

Cambrian Railways' coaching stock was attractively painted in a green-and-white livery scheme that contrasted favourably with the company's black locomotives. Although many of the Cambrian vehicles were six-wheelers, there were also a number of bogie coaches. Many of the trains seen on the route were through workings to the L&NWR system, and photographic evidence shows that North Western coaches were often attached to normal Cambrian services. Conversely, Cambrian vehicles worked through to Manchester or other destinations over the North Western system. Cambrian coaches lost their white upper panels after 1909.

Sweeping changes were made after the Cambrian Railways system became part of the GWR. Many of the Cambrian locomotives were withdrawn, while others (particularly the 0-6-0 goods engines) were re-boilered with standard Great Western boilers and fittings. Meanwhile, Dean Goods 0-6-0s, 'Duke' 4-4-0s, 'Barnum' 2-4-0s, '63XX' 2-6-0s

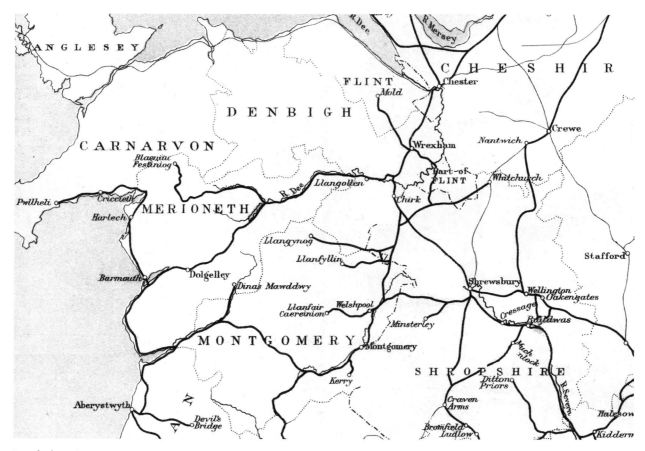

A Map of the Cambrian System

The Great Western system in mid-Wales and the borders, as depicted on a GWR publicity map of *c.* 1924. The Cambrian line commences at Whitchurch and runs generally south-westwards to Welshpool, from where the route meanders through Montgomery to the coast. The Aberystwyth line runs southwards to its destination, while the Pwllheli line is shown extending northwards via Barmouth and Harlech. Present-day trains run westwards from Birmingham International via Shrewsbury and Welshpool, taking the direct east-to-west line that can be seen on the map. Non-Great Western lines are not shown, although the GWR branches to Llanfair Caereinion, Kerry, Devil's Bridge, etc., are clearly shown.

and other GWR types were being transferred to the Cambrian section in considerable numbers to work alongside the remaining Cambrian engines.

In 1930, the GWR constructed a hybrid 4-4-0 locomotive using the frames of a withdrawn Bulldog 4-4-0. This engine became No. 3265 *Tre Pol & Pen*, and it was sent to Oswestry in July of that year. No. 3265 became the prototype of a whole class of rebuilds that utilised the frames of Bulldog 4-4-0s and parts from withdrawn Duke Class 4-4-0s. Although known officially as the Earl Class, the hybrid 4-4-0s soon became popularly known as 'Dukedogs' and, like the Dean Goods 0-6-0s, they were destined to enjoy a long association with the Cambrian line – no less than two dozen 'Dukedogs' being at work on the Cambrian system by 1947.

The Great Western was well-known for its standardised approach to locomotive construction, which resulted in the appearance of large numbers of 0-6-0PTs, 2-6-2Ts and 4-6-0 tender engines, these basic types being among the most successful engines on the Great Western system. It had always been intended that a 4-6-0 design would be developed as a replacement for the 43XX Class moguls, though in the event the first Manor Class 4-6-0 did not appear until 1938. The new engines had 18 inch by 30 inch cylinders, and 5 foot 8 inch coupled wheels, their axle loading being little more than 17 tons. The new engines did not immediately appear on the Cambrian route – possibly because the 'Dukedogs' had been more successful than anticipated. Nevertheless, the Manors were at work on the Cambrian line by 1943. Another Great Western class used on the Cambrian line were the Collett 2251 Class 0-6-0s. These sturdy locomotives were introduced in 1930 as replacements for the earlier Dean Goods 0-6-0s, and they were used for both passenger and goods work.

Left: **Whitchurch**
Dean Goods locomotive No. 2565 at Aberystwyth during the 1930s.

Whitchurch

Whitchurch was, for all intents and purposes, the eastern terminus of the original Cambrian main line. This former London & North Western station was opened on Wednesday 1 September 1858, when the Shrewsbury & Crewe Railway was brought into use. In operational terms, Whitchurch was the junction for L&NWR services to Chester via Tattenhall Junction, as well as Cambrian services to Oswestry, Aberystwyth and Pwllheli – the Tattenhall Junction line having been opened on 1 October 1872, ostensibly to provide the North Western Co. with a direct line to Chester and North Wales, though in practice this 15-mile line was treated as little more than a branch, with a service of around seven trains each way during the LMS period.

The infrastructure provided at this country junction included four platform faces, together with an engine shed, a turntable, and other facilities for terminating services. Like many other rural stations, Whitchurch was run down during the 1960s as the local railway system was progressively 'pruned'. The Tattenhall Junction route lost its passenger services with effect from 16 September 1957 while, as we have seen, the line from Buttington was deleted from the railway system in 1965. Whitchurch station nevertheless remains in operation, albeit as an unstaffed halt with minimal facilities for the travelling public. The upper picture is looking south towards Shrewsbury, the Cambrian line being visible just beyond the signal box. The lower view is looking northwards in the opposite direct; both photographs date from the early 1960s.

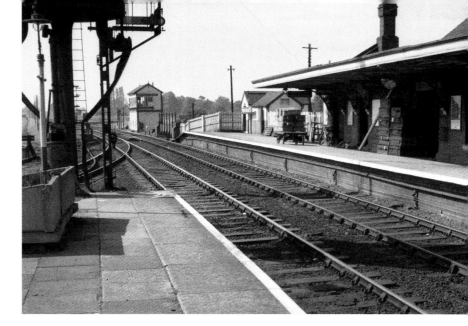

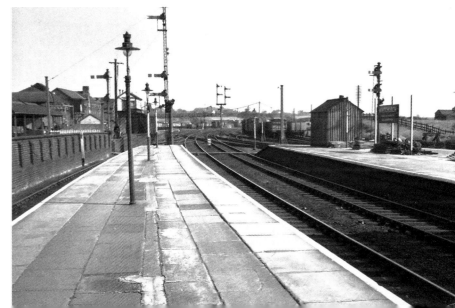

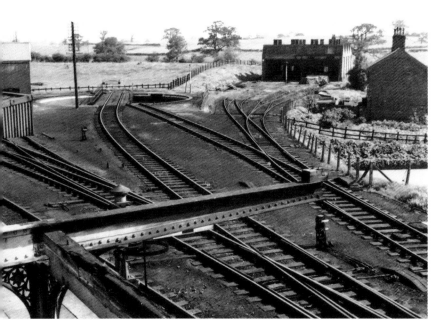

Right: Fenn's Bank

On leaving Whitchurch, the single track Cambrian route headed south-westwards for a distance of around 2 miles before trains crossed the invisible border between England and Wales. Fenn's Bank, the first intermediate stopping place, was a little under 3 miles from Whitchurch. The track layout here incorporated a single platform on the Up (or eastbound) side, together with a loop line and a goods yard on the Down side of the running line. A single-span arch bridge carried a minor road across the line immediately to the west of the platform, while the Llangollen Canal passed beneath the railway to the east of the station. A private siding connection on the Oswestry side of the road overbridge served the Peat Moss Litter Works, while another private siding catered from the needs of a local brickworks. The accompanying photograph shows the station during the British Railways period, around 1958.

Left: Whitchurch – The Engine Shed

Whitchurch engine shed was situated to the east of the passenger station. The shed building was a four-road structure with a 'northlight' roof, while other facilities included the usual coaling stage and a 60 foot diameter locomotive turntable. This former London & North Western shed was a sub-shed of Crewe (North) and, as such, it normally housed an assortment of small and medium-sized LMS locomotives, including Class 4MT 4-6-0s, Class 2MT 2-6-0s and Class 2P 4-4-0s. There was no regular allocation after 1957, although the shed continued to be used by locomotives on running-in turns from Crewe Works.

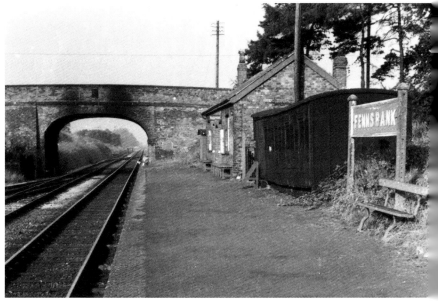

Bettisfield

From Fenn's Bank, down workings proceeded generally south-westwards across Fenn's Moss, which had caused so many difficulties during the construction of the railway in the 1860s. Bettisfield, the next stopping place (6¾ miles) had a nineteen-chain crossing loop, although the layout was not suitable for crossing two passenger trains, as there was just one platform on the Up side. The brick-built station building featured a two-storey stationmaster's house, while the goods yard could handle a full range of traffic, including coal, minerals, livestock, general merchandise and vehicular traffic. The 1938 Railway Clearing House *Handbook Of Stations* shows that there was also a private siding used for peat traffic by the Midland Moss Litter Co. – the last mentioned facility being situated beyond the confines of the station, around half a mile to the east.

The signal box, which was sited to the west of the platform on the Up side, was a typical Cambrian Railways structure with a gable roof and a brick-built locking room. The box could be switched out to facilitate 'long section' working between Ellesmere and Whitchurch; when 'short section' working was in use, the Ellesmere to Bettisfield and Bettisfield to Fenn's Bank single line sections were worked by Tyer's No. 6 Tablet.

If earlier plans had come to fruition, Bettisfield would have been elevated to junction status – the Wrexham, Mold & Connah's Quay Railway having initially intended to construct a line from Wrexham to Bettisfield. In the event, this scheme was never implemented, and Ellesmere, rather than Bettisfield, eventually became the junction for branch services to Wrexham. The upper picture shows the station during the 1950s, while the lower picture is a detailed view of the station building.

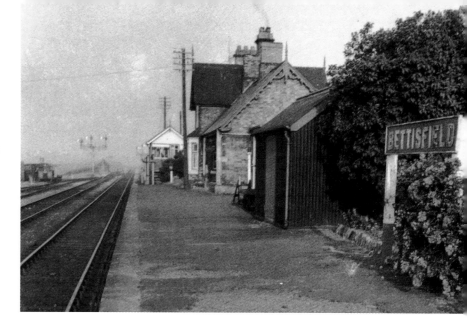

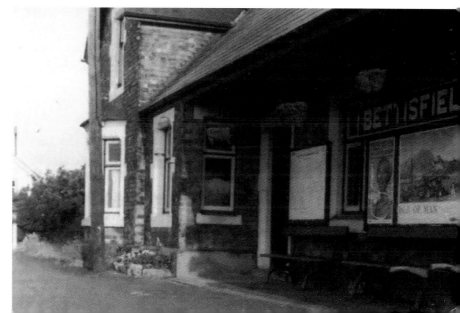

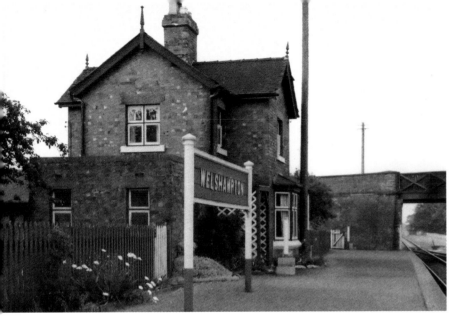

Welshampton

Curving on to a westerly heading, the single line continued to Welshampton (7¾ miles) which, like other stations on this section of the route, had been opened on 4 May 1863. Welshhampton was one of the smaller intermediate stations, and its modest facilities comprised a single platform for passenger traffic and a dead-end goods siding, the passenger facilities being on the Up side, while the goods siding was on the Down side of the single running line; there was no signal box, and the station was not a block post. The photographs show this wayside station during the 1960s.

Welshampton was the scene of a serious derailment that took place on 11 June 1897, the train involved in this accident being an Up excursion, which was returning from mid-Wales to Lancashire behind two locomotives. Eleven people were killed as a result of the mishap, which the Board of Trade Inspector attributed to excessive speed and the poor condition of the permanent way in the vicinity of Welshampton station. This version of events was disputed by the Cambrian Railways directors, who shamelessly tried to shift the blame by asserting that a Lancashire & Yorkshire Railway vehicle which had been marshalled at the front of the train had caused the derailment.

Opposite: Welshampton

A glimpse of Welshampton station during the early 1900s. The main station building can be seen to the right of the picture, while two coal wagons stand on the single goods siding.

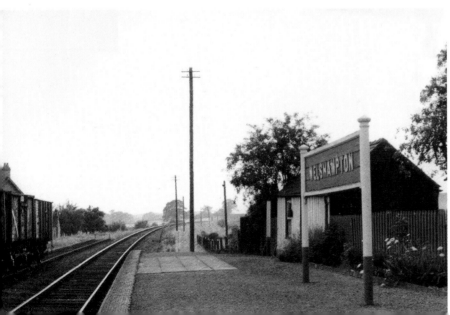

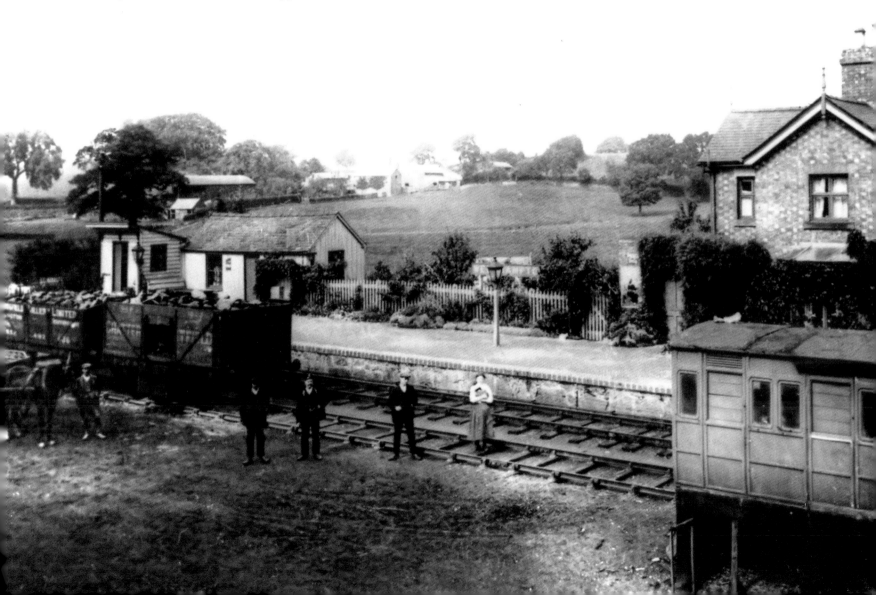

WELSHAMPTON. CAM. RLY.

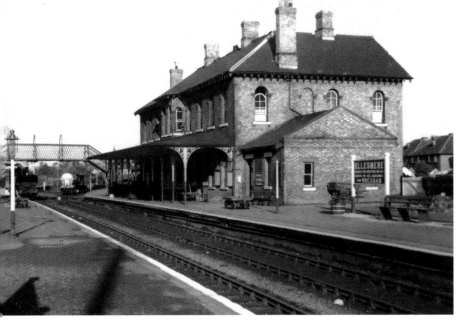

Ellesmere

On leaving Welshampton, Down trains headed due west for a short distance, before the route turned on to a south-westerly heading. As we have seen, Ellesmere (10¾ miles) was opened on 4 May 1863, and it became a junction on 2 November 1895, when the Wrexham & Ellesmere Railway was brought into use. The track plan at Ellesmere consisted of a 1,158 feet crossing loop, together with an array of goods sidings on each side of the running lines. Elson Road was carried over the line on a single-span brick bridge to the west of the platforms, while another road overbridge carried Grange Road across the line at the east end of the station.

The Wrexham & Ellesmere branch diverged northwards at 'Cambrian Junction', which was eleven chains to the west of Ellesmere station, and branch trains ran into the station from the west; a triangular junction was originally provided, but the little-used west-to-north arm was taken out of use during the early 1900s. Ellesmere had no branch bays, and for this reason Wrexham services arrived in the main Up platform and departed from the Down side. When it was necessary for incoming branch trains to connect with Up main line workings, there was an arrangement whereby both trains could use the Up platform. In such cases, the Up main line service was drawn forward towards the Up starting signal until its rearmost vehicle was clear of the up inner home signal. The branch train was then allowed to enter the platform, provided it was piloted from the Up branch intermediate home signal by a competent shunter or guard.

Ellesmere's station buildings were impressive; the main block on the Down side being a two-storey red-brick structure with gabled cross wings that faced the station approach, and a projecting bay window on the platform frontage. There was a platform canopy with graceful iron supports, and the upper floor windows were arched in the Italianate style. The upper view is looking east towards Whitchurch during the 1960s, while the lower view shows the rear of the main station building after closure.

Opposite: **Ellesmere**

A general view of Ellesmere station looking eastwards from the road bridge around 1962.

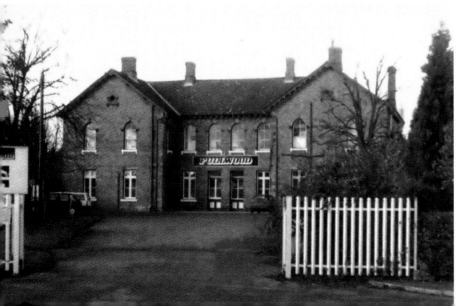

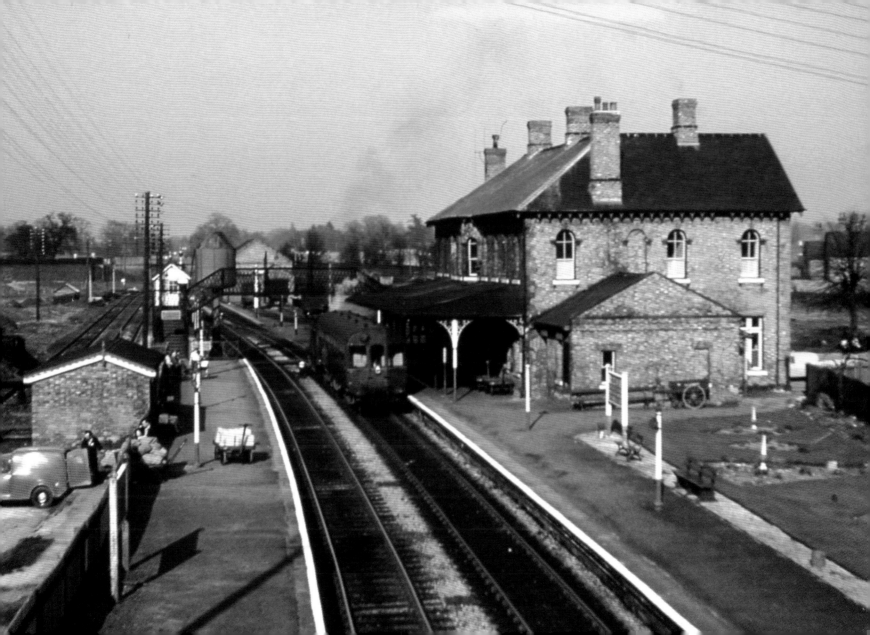

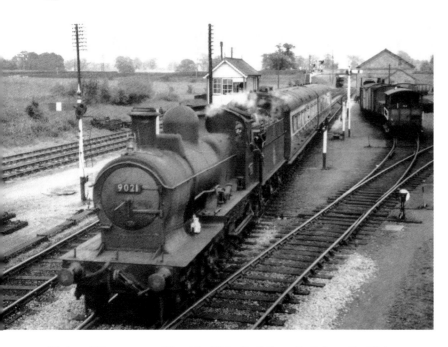

Right: Ellesmere – The Up Side Building & Other Facilities

Passenger facilities on the Up side were confined to a small waiting room with a low-pitched, slated roof, as shown in the accompanying photograph. This small structure had brick end walls and a timber façade. Until the 1930s, Ellesmere had been controlled from two signal boxes, known as Ellesmere and Ellesmere Junction; in 1930, however, the Junction box was closed and its instruments were transferred to the station box, which then had no less than five instruments. Other features of interest at Ellesmere included a lattice girder footbridge between the Up and Down platforms, a weigh-house and the usual assortment of permanent way huts and sheds. A mushroom-shaped water tank was available for branch trains on the main Up platform, while a locomotive turntable enabled tender engines to be turned to face the right direction before each journey; this facility was on the Up side of the running lines, and it had a diameter of 50 feet. At night, the platforms were lit by gas.

Left: Ellesmere – Passing the Goods Yard

'Dukedog' 4-4-0 No. 9021 enters Ellesmere with a down passenger working in June 1956. The goods yard, which can be seen to the right of the picture, contained a goods shed, coal sidings, cattle pens and a 6-ton hand crane. Additional siding facilities were provided on the Up side, these being entered via a connection that was trailing to Up trains. The traffic handled included coal, building materials, cattle, agricultural produce and road stone. Domestic coal was purchased in bulk by local coal merchants such as Thomas Chetwood, who was described in a 1900 trade directory as a 'coal, coke and lime dealer'. Ellesmere became a 'Country Lorry Centre' during the GWR period, railway-owned road vehicles were employed for collection and delivery work to and from places such as Hordley (4 miles from the station), Elson (1 mile) and Colemere (3 miles). In addition, the Great Western provided free collection and delivery services within the confines of Ellesmere itself.

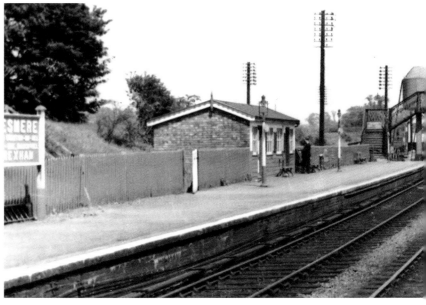

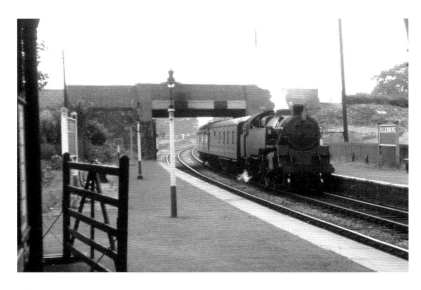

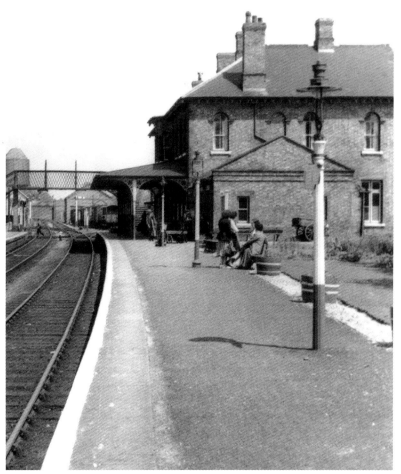

Ellesmere

Above: An unidentified BR Standard Class 4MT 2-6-4T enters Ellesmere station with an eastbound passenger train from Oswestry in September 1964.

Right: Looking eastwards along the down platform around 1962. Ellesmere was the scene of an accident on 6 November 1887 when a Down train was derailed as it approached the station. The accident was caused by faulty trackwork, but the Cambrian Railways management placed the blame on porter John Humphrey, who was dismissed from the company's service. Local opinion was aroused, and a petition was organised in support of the hapless porter. Furthermore, stationmaster John Hood signed the petition, and this inevitably brought him into conflict with the company, with the result that the stationmaster was himself subjected to victimisation. The dispute eventually reached the House of Commons, by which time the Cambrian Railways had been severely criticised for making its employees work excessively long shifts. John Hood was forced to leave the railway, but he happily received generous compensation, and continued to live in Ellesmere as a successful and much-respected local citizen.

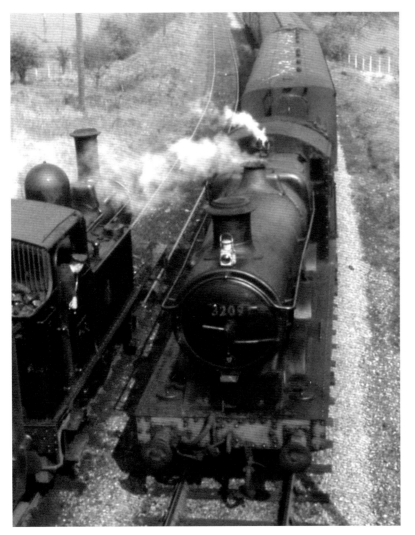

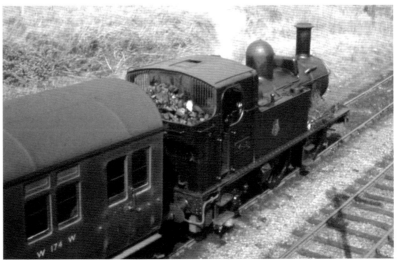

Ellesmere

Above: Collett 14XX Class 0-4-2T No. 1458 pauses on the Up main line at Ellesmere prior to setting back into the Down platform with a Wrexham branch working.

Left: Collett 2251 Class 0-6-0 No. 3209 arrives at Ellesmere with a train from Whitchurch in April 1962. The Wrexham branch train can be seen to the left of the picture. The first 2251 Class engines appeared on the Cambrian section during the later 1930s, and in 1947 Nos 2201 and 2244 were allocated to Oswestry, with Nos 2200, 2223, 2260, 2283 and 2298 shedded at Aberystwyth and Nos 2219 and 3201 at Machynlleth.

Ellesmere station was a significant employer in the local community, and in the mid-1930s the staffing establishment consisted of one Grade Two stationmaster, four clerks, four porters, one goods checker, one goods shunter, one goods carter, one motor driver and three signalmen. There was, in addition, a locally based permanent way gang consisting of one ganger, one sub-ganger and three or four lengthmen.

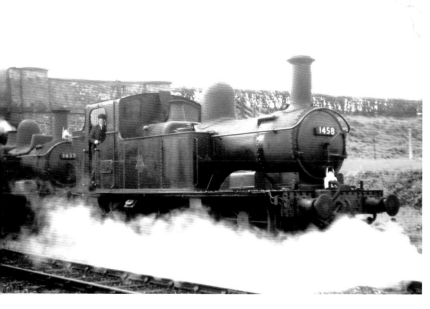

Left: Ellesmere

The final view of Ellesmere shows Collett 14XX Class 0-4-2Ts Nos 1432 and 1458 on the up main line during the early 1960s. From Ellesmere station, the route continued west towards Cambrian Junction, where the Wrexham & Ellesmere branch diverged from the main line. As their trains passed the site of the abandoned west curve, observant travellers may have caught a glimpse of a private siding known as 'The Old Loop Siding'. This short spur served a military supply depot that had been set up in a field near the old loop; the siding was entered via a connection which faced Up trains, and it cut across the trackbed of the loop at an angle. The GWR Register of Private Sidings reveals that the Old Loop Siding was removed in 1937, although it was later reinstated in connection with 'Ellesmere Magazine'.

Right: Frankton

Frankton (12¾ miles), the next stopping place, was a wayside station with a single platform on the Up side. The station was opened in 1867, and it boasted an impressive Jacobean-style station building, together with a small goods yard, the latter facility being sited to the west of the passenger station on the down side of the running line. It contained just one dead-end siding, which was entered by means of a connection that was facing to the direction of Up trains. The yard was able to deal with coal, livestock and general merchandise traffic. The picture shows the station around 1912, at which time an eight-lever signal box was still in use at the east end of the platform, although this small cabin was subsequently abolished.

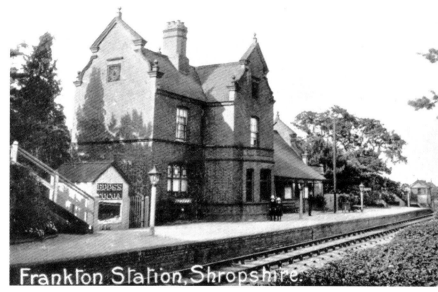

Frankton Station, Shropshire.

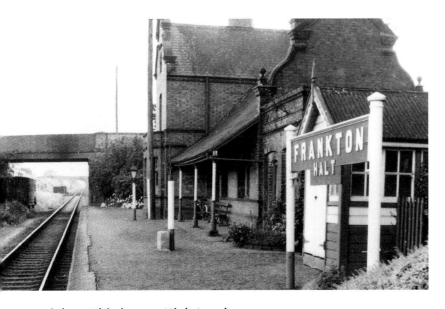

Left: Frankton

A further view of Frankton's large and ornate station building, which incorporated a two-storey stationmaster's house and a single-storey booking office wing. The internal arrangements included a first class waiting room and a retiring room, in addition to the usual booking office and waiting room accommodation. The station was officially renamed 'Frankton Halt' in 1955.

Right: Whittington High Level

Maintaining their south-westerly heading, trains continued through pastoral countryside towards Whittington (16¼ miles). Opened on 27 July 1864, Whittington was a two-platform station with a sixteen chain crossing loop. In operational terms, Whittington marked the start of a single line section that extended as far as Oswestry North Box, this section being worked by Tyer's No. 6 Tablets. However, it was possible for Whittington box to be switched out, in which case the Oswestry North to Ellesmere section became a 'long section' worked by the McKenzie & Holland square tablet system. In Cambrian days, the station had been known simply as 'Whittington', but after the 1922 grouping it was designated 'Whittington High Level' to distinguish it from the nearby GWR station, which became Whittington Low Level. With both stations under Great Western ownership, the former Cambrian station was placed under the control of the GWR stationmaster, while goods traffic was concentrated at Whittington Low Level – the High Level yard being used for occasional consignments of cattle.

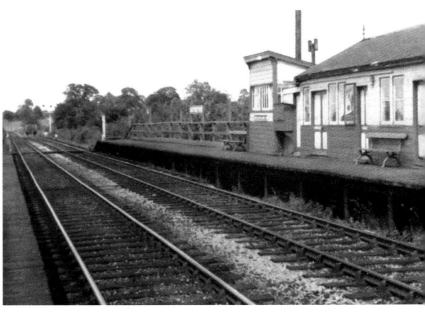

Tinker's Green Halt & Park Hall Camp

From Whittington, the line continued south-westwards, and after crossing over the Shrewsbury & Chester main line, trains reached Tinker's Green (17¼ miles). This single-platform halt was opened on 16 October 1939 to serve the adjacent Park Hall military camp. It consisted of a single platform on the Up side, together with a siding which diverged at the west end of the halt. The siding was entered by means of a connection that was facing to Up trains, and it ran directly into the camp. The camp had originated during the First World War, when a hutted encampment was established in the grounds of a large Tudor mansion known as Park Hall. Part of the site was later adapted for use as an orthopaedic hospital, the first patients being transferred from Baschurch in 1919, while the hospital was formally opened by the Marchioness of Cambridge on 5 August 1921.

The Park Hall site was reactivated for military purposes during the Second World War, and for the next few years the camp functioned as a military training centre. Most of the ordinary trains between Whitchurch and Oswestry called at Tinker's Green, and there was also a service of push-pull auto-trains from Oswestry. Park Hall Camp was, in addition, served by a halt on the Gobowen to Oswestry branch, though this stopping place was used mainly by visitors to Park Hall Hospital, which was sited to the north of the main camp in what had originally been the camp hospital. Tinker's Green Halt, in contrast, was more convenient for the Second World War camp, which remained in use for National Service recruits for several years after the war.

Oswestry – The Great Western & Cambrian Stations

Still heading south-westwards, the railway ran along a raised embankment that was pierced at one point by an underline bridge. Although the line was single track, there were sidings on each side of the running line which suggested, to uninitiated travellers, that they were running on a double track. Having passed beneath a long girder footbridge that gave access to Oswestry Works, trains entered Oswestry station, around 18¼ miles from Whitchurch, and an important traffic centre with lengthy Up and Down platform lines together with a third, or 'middle road' that was signalled for through running in both directions.

In pre-grouping days, Oswestry had boasted two stations: the Shrewsbury & Chester Railway station having been opened for public traffic on 1 January 1849 as the terminus of a branch from Gobowen, whereas the neighbouring Oswestry & Newtown station was opened in 1860. The two stations were linked by a connection at the north end, and there was an additional link through the Great Western goods yard, but there were no covered footways or luggage lifts, and this caused considerable difficulties for through travellers. To eradicate this problem the GWR implemented a rationalisation scheme after the 1922 grouping, whereby all passenger traffic was concentrated in the former Cambrian station, and the Great Western terminus became part of an enlarged goods yard.

The remodelling was carried out in 1923/24, over £60,000 being spent on platform extensions and other work. The Cambrian platforms were lengthened by 300 feet and a Gobowen branch bay was created on the west side of the station, while at the same time the main Up and Down platforms were equipped with new canopies, and electric lighting was installed in place of gas lamps in the goods yard and engine sheds. The upper picture shows the former GWR terminus after closure to passengers, while the lower illustration provides a general view of the station, looking south-west towards Welshpool with the Gobowen branch bay to the right of the picture.

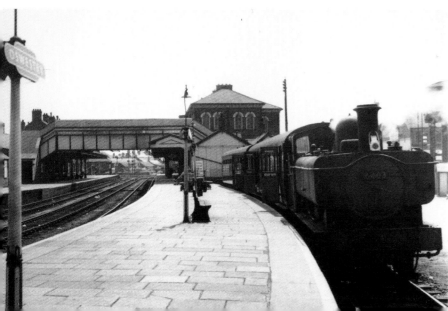

Oswestry – The Station Buildings

The main station buildings at the Cambrian station were large and impressive. The main block, on the Up side, was a two-storey red-brick structure, with a low-pitched hipped roof punctuated by six squat chimney stacks. There was a projecting bay window on the platform frontage, and the platform was protected by a large canopy. Internally, this distinctive structure contained a range of accommodation for staff and passengers, including booking office and waiting room facilities, together with a telegraph office and a much-frequented refreshment room. Interestingly, the style of architecture employed at Oswestry was very similar to that employed elsewhere on the Cambrian and its constituents during the 1860s; Llanidloes, for example, was built to more or less the same plan, while a substantially similar station building could be seen at nearby Ellesmere.

Further buildings were available on the Down platform, the main block being another two-storey brick structure with a low-pitched hipped roof. The Up and Down side station buildings were superficially similar, the resemblance being accentuated by the provision of round-headed, Italianate window openings on both structures. There were, in addition to the two main blocks, a number of single-storey buildings and extensions on both platforms, and these provided a variety of accommodation, including parcels and left luggage facilities, offices and porters' mess rooms. The upper view shows the main station building, while the lower view shows the north end of the station, looking towards Whitchurch with Oswestry Works visible to the right.

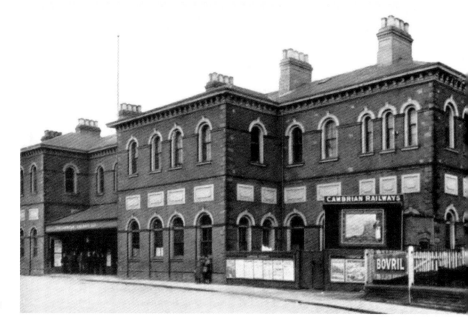

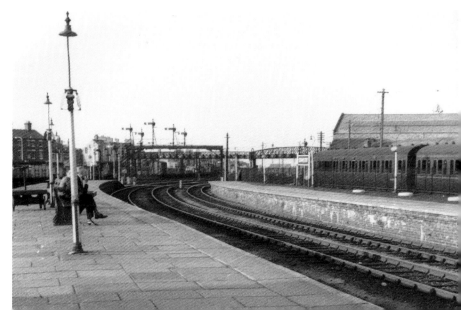

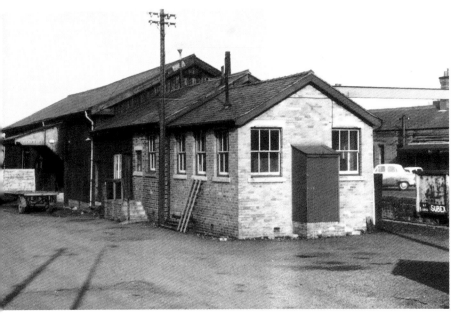

Above: Oswestry – Goods Facilities & Other Infrastructure

Goods facilities were provided on a lavish scale, with sidings at both the north and south ends of the station. The main goods yard, which incorporated the original GWR terminus, was situated to the north of the passenger station, and further goods sidings were available to the south of the Up platform. The south end yard contained the Cambrian Railways goods shed – a large, gable roofed structure with a spacious internal loading platform. Connecting sidings extended southwards and south-westwards from the Cambrian goods yard to serve cattle loading pens and an adjacent timber yard. On the Down side, a multiplicity of goods loops and carriage sidings extended along the eastern side of the station behind the down platform. The goods loops provided a means of access to the neighbouring Cambrian Railways workshops, which dominated the landscape to the north-east of the passenger station.

Below: Oswestry – Signalling Details

At the time of the grouping, Oswestry was signalled from two Great Western signal boxes and three Cambrian cabins, but both GWR boxes and two of the Cambrian cabins were abolished as part of the changes initiated in 1923–24, and the station was then signalled from a new Oswestry central box in the 'V' of the diverging Whitchurch and Gobowen lines. The new cabin was originally equipped with a seventy-eight-lever frame, though the number of levers was subsequently increased to ninety-six. The signal box was soon renamed Oswestry North Box to distinguish it from the former Cambrian South Box, depicted here, which remained in use at the opposite end of the station.

Opposite: Oswestry

A panoramic view of the station, looking south-westwards from the GWR goods yard. The platform ramp of the former Great Western passenger station can be seen on the extreme right.

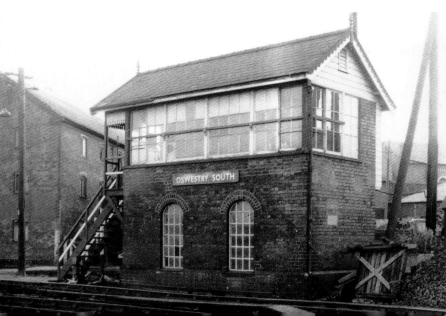

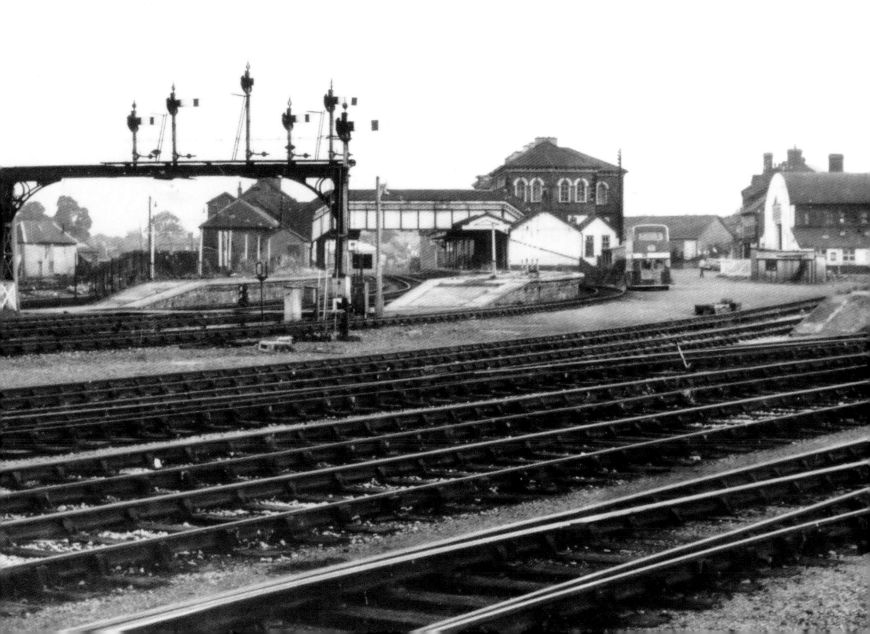

To NORTH & CENTRAL WALES & CAMBRIAN COAST
(Via CHESTER, GOBOWEN and OSWESTRY)

Friday and Saturday, May 22nd and 23rd
To return on any week-day up to and including Saturday, June 6th ; also on
Wednesday & Thursday, May 27th & 28th
To return on any week-day up to and including Thursday, June 11th.

FROM			TIMES OF STARTING			Return Fares,	Return Times	
MANCHESTER (Exchange)		a.m. 7b 25	a.m. 10a 50	p.m. 1c 35	Third Class		
TO			TIMES OF ARRIVAL				Mondays to Thursdays inclusive	Fridays and Saturdays
				p.m.	p.m.	s. d.		
Aberdovey	1 55 pm	4 53	8S 27	17 6		10 25 am
Aberystwyth	2 15	5 5	8 50	20 9		10 15
Borth	1 53	4 49	8 28	19 9		10 33
Brecon	NB	7 25	NB	24 0		7 15
Builth Road	NB	6 10	NB	20 3	By any	8 25
Builth Wells	NB	6 15	NB	20 6	Ordinary	8 18
Llanidloes	12 51	4 11	8 12	17 3	Train	11 20
Llanymynech	11 8	3 19	5 24	11 3	having a	10 57
Machynlleth	1 17	4 25	7 56	17 6	Through	11 0
Montgomery	11 49	3 25	6 34	14 0	connection.	12 10 pm
Newtown	12 13	3 36	6 49	15 0		11 57 am
Rhayader	NB	5 46	9S 2	19 6		8 50
Talgarth	NB	6 55	NB	22 6		7 40
Towyn	2 2	5 0	8S 34	17 6		10 20
Welshpool	11 31	2 58	5 51	13 0		12 28 pm

Notes.
a—Change at Chester and proceed at 12.20 p.m. Change at Gobowen and Oswestry and proceed from Oswestry at 2.33 p.m. (3.3 p.m. for Llanymynech). b—Change at Chester and proceed at 9.40 a.m. (through coach Chester to Aberystwyth).
c—Dep. 1.45 p.m. Saturday, May 23rd. Change at Chester and proceed at 3.12 p.m. S—Saturdays only. N.B.—No bookings.

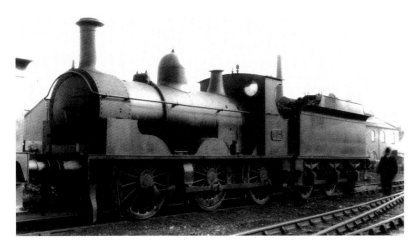

Above: **Through Services from Manchester**
This Great Western public notice was issued in 1931, and it provides details of the through services that ran between Manchester and the Cambrian Coast via the Gobowen and Oswestry route.

Below: **Oswestry Works**
Oswestry Works was situated to the north-east of the station. The factory continued to undertake heavy repairs after the Great Western takeover, around 400 people were employed in the engine shed and the locomotive, carriage and wagon shops during the 1920s and '30s. The works site encompassed an extensive range of brick buildings, a variety of facilities being available for all forms of locomotive and rolling stock construction and maintenance work. The works was equipped with traversers and overhead cranes, as well as smaller machinery such as lathes, saw mills and woodworking machinery. Power for the works machinery was supplied by a two-cylinder steam engine and there was at least one smaller engine in the woodworking department, while steam was supplied a battery of locomotive boilers, which also supplied steam for heating the extensive works site. The picture shows Cambrian Railways 0-6-0 No. 79 (as GWR No. 882) outside the works building. This locomotive was built by the Vulcan Foundry in 1894, and it remained in use until January 1935.

Oswestry Shed

Oswestry engine shed was situated to the north of the station on the Up side of the running lines. It contained six terminal roads, the main building being approximately 200 foot long and 70 foot wide. A standard GWR raised coaling plant was erected as part of the post-grouping improvements, and this replaced an earlier Cambrian coaling stage. The Great Western coal stage was surmounted by a 45,000-gallon water tank, while the old 45-foot-diameter engine turntable was taken up and a new 65-foot-diameter GWR erected. Other facilities added in the 1920s included new offices, workshops, stores and a sand-drying furnace. In 1948, the shed housed thirty-six locomotives, including two Manor Class 4-6-0s; six 'Dukedog' 4-4-0s; five 2251 Class 0-6-0s; four Dean Goods 0-6-0s; four ex-Cambrian 0-6-0s; and fifteen tank locomotives of various kinds.

The upper photograph shows Cambrian Railways 0-6-0 locomotive No. 48, a Sharp Stewart six-coupled tender engine dating from 1878, which originally worked on the Mid-Wales Railway as MWR No. 9. The locomotive became GWR No. 908 at the grouping, and was withdrawn in 1938. In its final years the engine was shedded at Oswestry, and employed mainly on local branch line duties. The lower view depicts an unidentified Cambrian Railways 0-6-0 (possibly No. 838?), photographed at Oswestry in Great Western days, but still in Cambrian condition, apart from the addition of a GWR style safety valve cover.

The Gobowen to Oswestry branch service was withdrawn with effect from 7 November 1966, the last trains being run on Saturday 5 November. Oswestry Works was officially closed at the end of 1966, and much of the trackwork around the station and works was subsequently removed, leaving a few sidings and a single line through the station, which was needed in connection with stone traffic to nearby Nantmawr Quarries (on the former Oswestry & Newtown line near Blodwell station). In recent years Oswestry has become the headquarters of Cambrian Heritage Railways – an amalgam of the Cambrian Railways Society and the Cambrian Railways Trust – which is hoping to restore railway services between Gobowen, Llynclys and Blodwell.

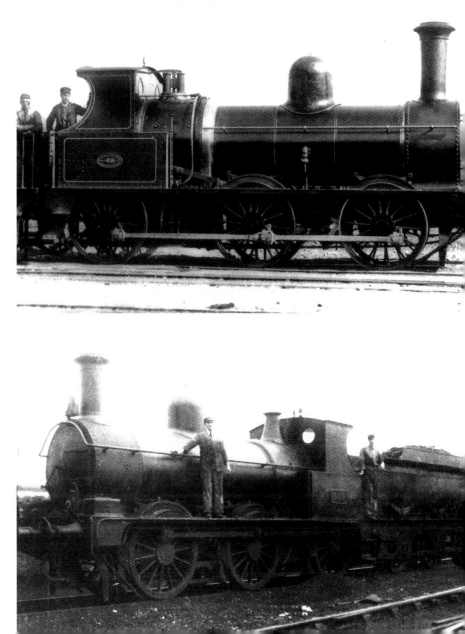

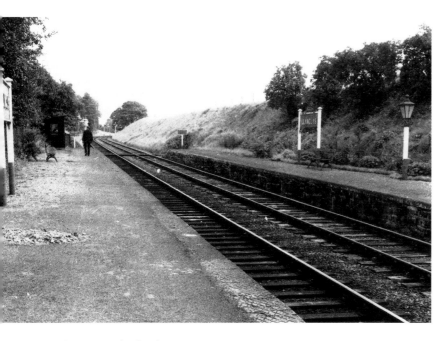

Left: Llanclys

On leaving Oswestry, down trains ran southwards along a section of double track, passing Llynclys Junction en route, where the Tanat Valley Railway diverged westwards on its way to Blodwell Junction and Llangynog. The Tanat Valley line was opened by the Cambrian Railways on 5 January 1904, and it was worked as a branch between Oswestry and Llangynog, ex-Cambrian Seaham Class 2-4-0Ts Nos 1196 and 1197 being used on the route for many years. Llynclys, the next stopping place (22 miles), was situated a short distance beyond the junction. This wayside station boasted a small but substantial station building on the Up side, and a waiting shelter on the Down platform. In architectural terms the station building, with its two-storey stationmaster's house and single-storey booking office wing, was typical of Oswestry & Newtown practice. The nearby goods yard contained facilities for coal, livestock and general merchandise traffic.

Right: Pant (Salop)

From Llanclys, trains continued southwards along the double track section to Pant (23¼ miles). This small station was opened by the Oswestry & Newtown Railway in 1862, and its modest facilities consisted of Up and Down platforms for passenger traffic and a small goods yard. Trains initially called on Mondays, Wednesdays and Saturdays only, but a full service was introduced in 1865. The main station building was on the Up side, and there was a timber-framed waiting room on the Down platform, together with a typical Cambrian Railways gable-roofed signal cabin with a sixteen-lever frame. The photograph shows the down platform during the early 1960s. All of the stations on this section of the line were closed (with the exception of Oswestry) with effect from 18 January 1965.

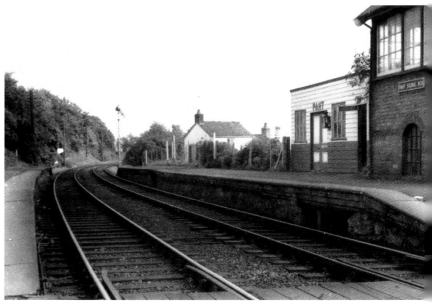

Lanymynech

Llanymynech (24¼ miles), the next stop, was opened on 1 May 1860. It became the junction for branch services to Llanfyllin, and also the junction for local services to Shrewsbury, which ran eastwards over the archaic and eccentric Shropshire & Montgomeryshire Light Railway. The station boasted five platforms, comprising Up and Down platforms for main line services, an Up bay and two additional platforms for branch line traffic – the branch line platforms being on the east side of the station. Despite its Welsh name, Llanymynech station was situated on the English side of the border - indeed, Offa's Dyke, which marked the historic boundary between England and Wales, ran through the parish.

Llanymynech itself was a largely Victorian village, which first became important following the opening of a branch of the Ellesmere Canal in 1796. The original waterway was extended from Carreghofa to Welshpool by the Montgomery Canal in 1797, and in 1815 the latter canal was itself extended to Newtown. These waterways later became part of the Shropshire Union Railways & Canal Co. and, as such, they passed into London & North Western Railway hands. Final abandonment took place under LMS auspices in 1944.

The upper photograph is looking south towards Welshpool during the early 1960s; an unidentified Manor Class 4-6-0 is standing in the up main line platform with a three-coach passenger working, while the goods yard can be seen to the right. The lower view is looking north-west towards the station buildings from the road overbridge, the building in the foreground being on the Down main platform.

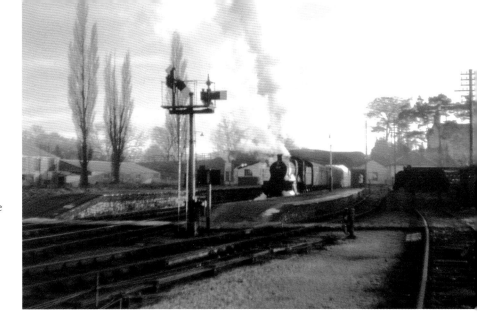

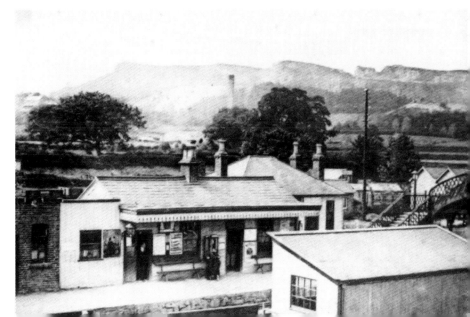

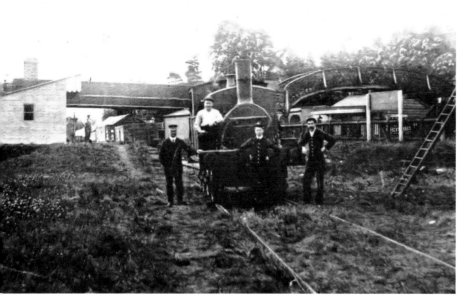

Lanymynech – The Shropshire & Montgomeryshire Railway

The presence of the Shropshire & Montgomeryshire line added an element of complexity to the railway history of Llanymynech. The line was opened as the grandly named 'Potteries, Shrewsbury & North Wales Railway' on 13 August 1866 and, as its name implied, the undertaking was originally promoted as part of a cross-country link between the Midlands and North Wales. Having failed to reach its intended destinations, the railway never achieved main line status. In fact, traffic was so poor that most of the line was closed in 1880, though on 12 April 1911 the Shrewsbury to Llanymynech portion was re-opened as 'The Shropshire & Montgomeryshire Light Railway' by Col Holman F. Stephens.

In the meantime, the western end of the former Potteries, Shrewsbury & North Wales line had been leased to the Cambrian Railways, which thereby gained access to Nantmawr Quarries. The PS&NWR line had originally crossed the Cambrian main line on the level, but when the Llanfyllin branch was opened in 1863 a bridge was necessary in order that branch trains could cross the PS&NWR route. Further changes ensued in 1896, when a connection was established between the Nantmawr line and the Llanfyllin branch, so that Llanfyllin branch trains could serve Llanymynech station without reversing.

The Shropshire & Montgomeryshire Railway was closed to regular passenger traffic in November 1933, but the line was taken over by the army in 1941, and for the next few years the S&MR served ammunition depots and other military facilities. The upper picture shows a locomotive in the former PS&NWR station at Llanymynech, the overgrown nature of the trackwork suggesting that the photograph was taken prior to the 1911 reopening. The lower view shows War Department locomotive No. 70099, a Dean Goods 0-6-0, in a derelict condition on the Shropshire & Montgomeryshire line.

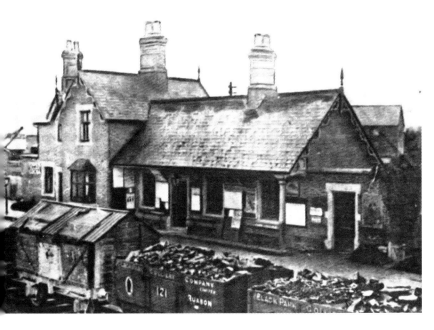

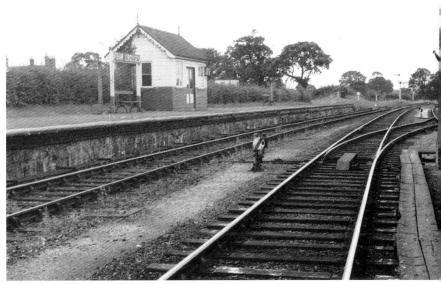

Left: Four Crosses – The Main Station Building

On leaving Llanymynech, trains crossed the border between Shropshire and Wales and proceeded southwards for a little under 2 miles to Four Crosses (25¾ miles). Opened by the Oswestry & Newtown Railway on 1 May 1860, this station was a crossing place with staggered platforms, the Down platform being further south than its counterpart on the Up side. The main station building, on the up side, was a substantial brick-built structure incorporating a two-storey stationmaster's house and a single-storey booking office and waiting room – the domestic portion being to the left (when viewed from the platform), as shown in this Edwardian view of around 1908.

Right: Four Crosses – The Down Platform

The goods yard, also on the Up side, was able to handle a full range of traffic including coal, livestock, horse boxes, furniture and general merchandise, while a 6-ton crane was available for loading or unloading large or heavy consignments. Improvements carried out during the Great Western period included an extension of the crossing loop and the provision of a new signal box – the latter structure being a gable-roofed building with twenty-six levers. The picture provides a glimpse of the staggered Down platform, with its simple, timber-framed waiting room.

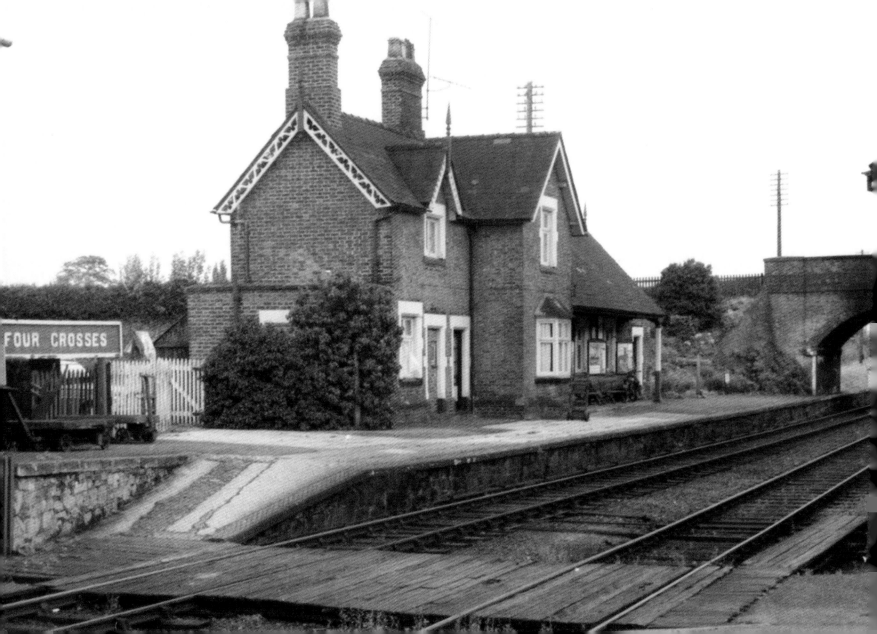

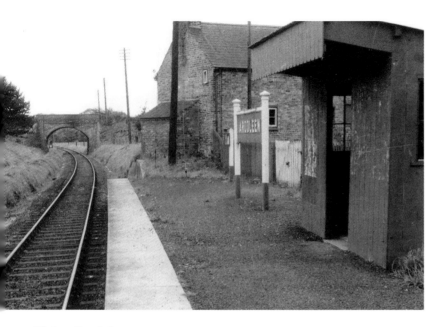

Left: Arddleen Halt

Arddleen, the next stopping place (27½ miles), first appeared in the timetables during the early 1860s, although the advertised services were extremely limited, and trains stopped only on Mondays, Wednesdays and Saturdays. This meagre service persisted for many years, the station being regarded merely as a request stop, with minimal facilities for the occasional traveller. The infrastructure consisted of a short platform on the Up side of the single line, together with a brick-built cottage that pre-dated the railway, but was nevertheless known as the 'Station House'. In later years, the platform was equipped with a simple waiting shelter, though it is believed that a slightly larger building had originally been provided. This passenger-only stopping place was officially designated 'Arddleen Halt' in 1954.

Right: Pool Quay

Pool Quay (29¼ miles), a little under two miles further on, was a more important station with Up and Down platforms on either side of a crossing loop. It was opened by the Oswestry & Newtown Railway on 1 May 1860 and closed with effect from 18 January 1965, when passenger services were withdrawn from the Whittington to Welshpool line. The A483 road crossed the line on the level at the north end of the platforms, the main station building was on the Up platform. There was a simple waiting shelter on the Down side, while the standard Cambrian gable-roofed signal cabin was sited on the Down side in convenient proximity to the level crossing – the gates being worked by a gate wheel.

Opposite: Four Crosses

A general view of Four Crosses station during the early 1960s.

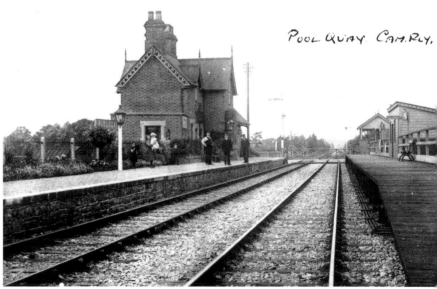

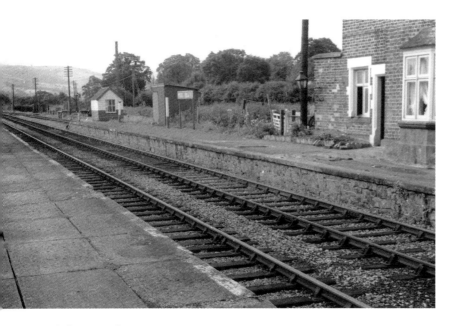

Left: Pool Quay

This *c.* 1960s view of Pool Quay station is looking south towards Aberystwyth, the goods yard being visible at the rear of the Up platform. The station building, which can be glimpsed to the right of the picture, was typical of those provided at the smaller intermediate stations on the Oswestry & Newtown Railway and other constituents of the Cambrian system. It incorporated a two-storey stationmaster's house and a single-storey waiting room block – the house portion, in this instance, being to the left of the waiting room (when viewed from the platform). The building was of brick construction, while the gables were graced by decorative barge boards and pointed finials. The front of the waiting room was set back beneath the gable roof to form a covered waiting area for passengers – this feature being found at other small stations on the Cambrian route.

Right: Buttington

From Pool Quay, the railway continued southwards to Buttington (31¼ miles), at which point the Shrewsbury & Welshpool line converged with the former Oswestry & Newtown route. This station was opened in 1860 and it became a junction when the Shrewsbury & Welshpool route was brought into use on 27 January 1862. Up and down platforms were provided for both routes, the two sets of platforms being laid out on a diverging alignment, with the main station buildings in the 'V' of the junction. There was a small goods yard, while a private siding served the nearby Buttington Brick & Tile Works. The photograph shows former Lancashire & Yorkshire Railway 27 Class 0-6-0 locomotive No. 12141 with a passenger train in the Up Shrewsbury platform, the substantial brick-built station building being visible to the right. Buttington station was closed with effect from 12 September 1960, five years before the withdrawal of passenger services from the Whittington line.

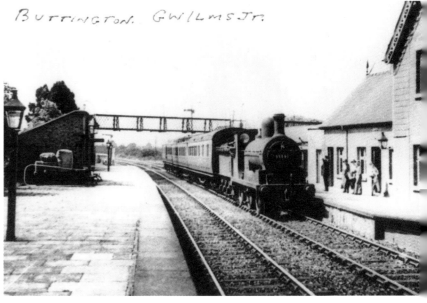

Buttington. GW/LMS Jn.

Shrewsbury

Having looked at the closed section between Whitchurch and Buttington Junction, it would now be convenient to examine the still-extant line between Shrewsbury and Welshpool, which forms the eastern end of the present-day 'Cambrian Line' (although it was never part of the Cambrian Railways).

Opened by the Shrewsbury & Chester Railway on 14 October 1848, Shrewsbury station is one of the finest examples of 'railway Gothic' architecture in these islands. The main block, designed by local architect Thomas Mainwaring Penson (1817–64), is three stories high, with a clock tower and romantic, mullioned and transomed windows. The station was considerably enlarged in 1855, and there was a further reconstruction at the end of the Victorian period, when the cellars beneath Penson's original building were opened out and adapted for use as a booking office and other accommodation – a new entrance and subway being provided as part of the rebuilding scheme. There was, at one time, a cavernous overall roof, but this has long since been removed, resulting in a more spacious and much less claustrophobic atmosphere.

The upper view, from an Edwardian colour-tinted postcard, shows the main façade around 1912, while the lower photograph illustrates the opposite side of the building during the early 1960s. The pedestrian footbridge that can be seen in the background carries a public footpath across the railway; the bridge is known locally as 'The Dana', presumably because it led to the now-closed Shrewsbury Prison, which was built on the site of a medieval prison known as the Dana Gaol.

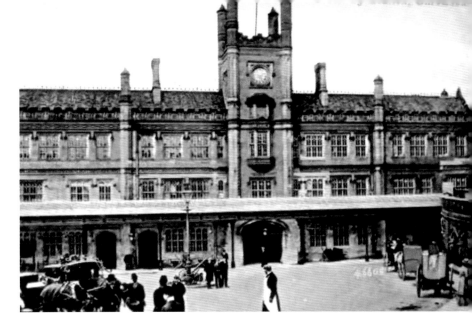

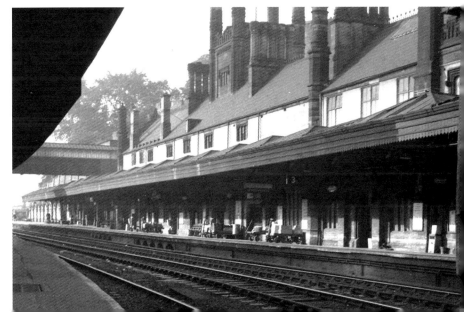

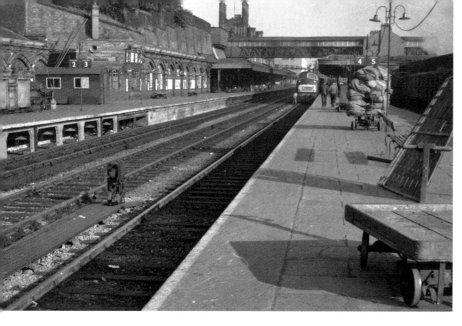

Above: Shrewsbury

Until 1954, the platforms had been numbered from 1 to 10, but they have latterly been numbered from 1 to 7. The operational side of the station has three long through platforms, which are numbered 3, 4 and 7, and four terminal bays, the latter being designated platforms 1, 2, 5 and 6. At one time, Platform 3, on the west side of the station, was used mainly for parcels traffic and football specials, but it has latterly been brought back into full use for main line traffic. Platforms 5 and 6, at the south end of the main island platform, are used by terminating services from the Cambrian and Central Wales lines, but platforms 1 and 2, at the south end of Platform 3, have now lost their trackwork. The photograph shows Platform 4, which is 1,013 feet in length, while Platform 3, visible to the left, can accommodate thirteen bogie coaches.

Below: Shrewsbury – Signal Boxes

The signalling at Shrewsbury station was formerly controlled from three signal cabins, which were known as Severn Bridge Junction Box, Shrewsbury Central Box, and Crewe Junction Box. The Central Box, which had been situated in an elevated position above platforms 5 and 6, was abolished in 1961, and the station was then signalled from the remaining Crewe Junction and Severn Bridge Junction boxes. Both of these cabins are of standard L&NWR design – Severn Bridge Junction Box being an enormous specimen, with a 192-lever frame; this giant box was erected in 1902. Other signal cabins were located at Abbey Foregate, English Bridge Junction (closed in 1955) and Sutton Bridge Junction, on the outskirts of Shrewsbury, which is pictured here on 2 September 2000. This standard Great Western Railway box controls the routes to Hereford and Aberystwyth, the points in the foreground forming a facing crossover that enables Cambrian line trains bound for Wales to gain access to the single line.

Opposite: Shrewsbury

Class 47 locomotive No. 47759 swings round the curve at Sutton Bridge Junction with the 6.47 a.m. Rose Grove to Cardiff 'St James Day Tripper' special on 13 May 2000. No. 47759 was one of the minority of Rail Express Systems locomotives that never received a Res themed name. It survived for another couple of years after this photograph was taken and then, after a lengthy period in store, the locomotive was finally cut up at Ron Hull's Rotherham yard in January 2008.

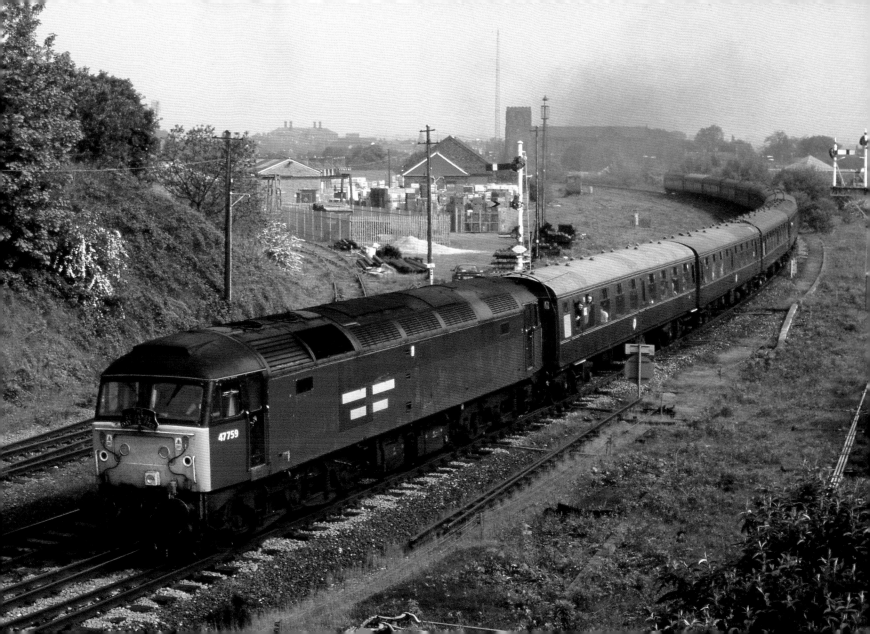

Right: Shrewsbury

Only the daffodils on the side of the cutting liven up this gloomy scene as Class 60 locomotive No. 60064 heads southwards past the semaphore signals at Sutton Bridge Junction while hauling the 9.29 a.m. Dee Marsh to Llanwern steel empties on 27 March 2004. Only one other locomotive carried this interim Loadhaul branded triple grey livery, the engine in question being No. 60070.

Left: **Shrewsbury – Passing Sutton Bridge Junction Box**

Class 158 unit No. 158833 approaches Sutton Bridge Junction Signal Box with the 7.20 a.m. Cardiff Central to Manchester Piccadilly service on 13 May 2000.

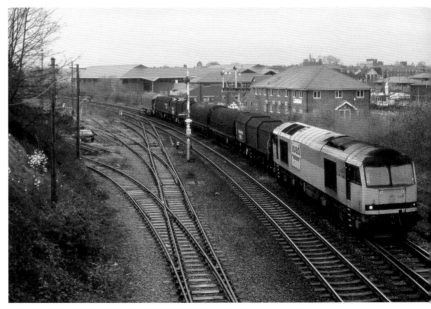

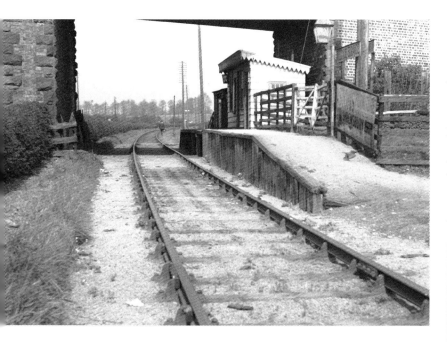

Left: Meol Brace

Climbing gradients as steep as 1 in 100, trains run south-westwards along what is now a single line, although in steam days this first section of the Shrewsbury & Welshpool route had been multiple-tracked – the former 'Potteries, Shrewsbury & North Wales' line being alongside the main line. As mentioned on page 35, the PS&NWR line was closed in 1880, but it was revived as 'The Shropshire & Montgomeryshire Railway' on 14 April 1911. The S&MR opened halts at Meol Brace and Hookagate, together with an array of exchange sidings which remained in use long after the withdrawal of passenger services from the Shropshire & Montgomery route in November 1933. The photograph shows Meol Brace halt around 1930, looking east towards Shrewsbury; the main line was situated just beyond the hedgerow on the left-hand side of the picture.

Right: Hookagate

Hookagate was similar to neighbouring Meol Brace, both of these stopping places being equipped with simple wooden buildings. The Shropshire & Montgomeryshire line was commandeered for military use during the Second World War, and Hookagate station was swept away to make room for new sidings serving nearby ammunition dumps. These sidings, on the Down side of the Shrewsbury & Welshpool main line, later became a long rail welding depot and, as such, they remained in use until 1986. Access to the sidings was controlled from a standard GWR brick-and-timber signal cabin that had been opened in 1942; the signal box had a twenty-four-lever frame and remained in use until 1973.

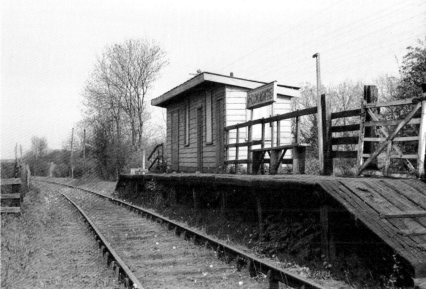

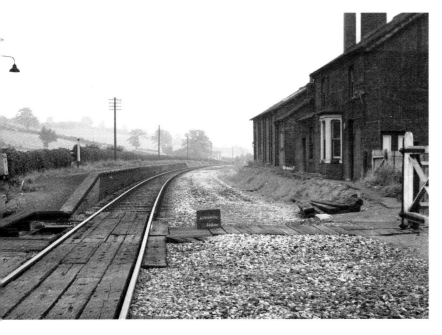

Right: Hanwood

Hanwood was closed to passengers with effect from 12 September 1960 and the photographs on this page show the remains of the station after closure. The upper view is looking east towards Shrewsbury after removal of the Down platform, while the lower view is looking west towards Welshpool. The signal box was enlarged in 1954 when the frame was increased from sixteen levers to thirty-five. Hanwood lost its goods facilities in 1964.

Left: Hanwood

Hanwood (4¾ miles), the first intermediate stopping place on the Shrewsbury & Welshpool section, was opened on 14 February 1861 when trains began running between Shrewsbury and Minsterley. Its infrastructure consisted of Up and Down platforms for passenger traffic and a small goods yard – the goods yard being on the down side. A minor road crossed the line on the level at the west end of the platforms, and the main station building was on the Down side. In operational terms, Hanwood marked the end of the double track section from Sutton Bridge Junction, although the entire line has now been reduced to single track. The station was the setting for an accident that occurred on 23 October 1862, when a workmen's train was partially derailed and two wagons were overturned, precipitating around forty men down an embankment; two being killed outright while another eight were seriously injured.

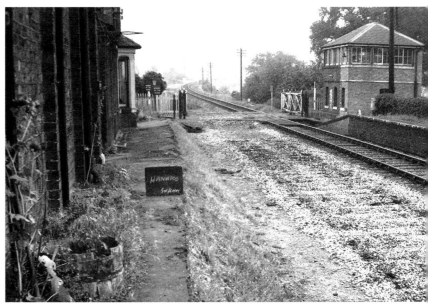

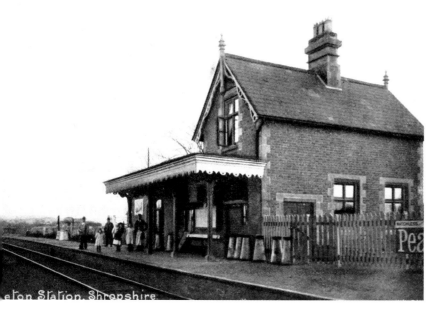

Right: Yockleton

A general view of the station, looking west towards Welshpool, probably during the mid-1930s. Former Lancashire & Yorkshire 27 Class 0-6-0 No. 12141 is standing beside the platform with what appears to be an LMS local passenger service. The arched road overbridge that can be seen in the background carried the B4386 over the railway. Yockleton became an unstaffed halt in July 1956, and the station was closed with effect from 12 September 1960.

Left: Yockleton

From Hanwood, trains head west-north-westwards to Yockleton, the site of a wayside station around 7½ miles from Shrewsbury. Opened on 27 January 1862, Yockleton had just one platform on the Down side, together with a small goods yard that was able to handle a full range of traffic, including coal, livestock, vehicles, horseboxes and general merchandise. The station building, pictured during the early years of the twentieth century, was an ornate, Tudor-Gothic style structure that incorporated domestic accommodation for the stationmaster and his family, as well as the usual booking office and waiting room facilities.

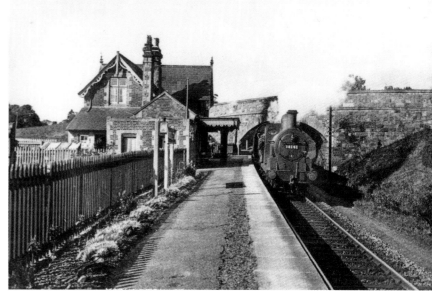

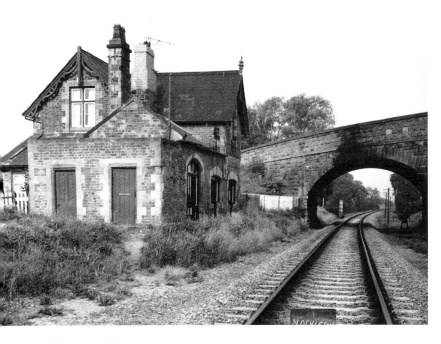

Right: Yockleton

The final view of Yockleton, which was obviously taken on a misty winter's day, is looking eastwards through the arch of the road bridge, with the station building featuring prominently to the right of the picture. This Victorian building has remained in existence as a residential property, and it can still be seen as present-day trains rush past the site of the former station; the waiting room wing has been heightened by the addition of a flat-roofed upper storey, but the building is still recognisable as a former station.

Left: Yockleton

This post-closure photograph, taken in the 1960s, provides an interesting comparison with the earlier pictures. The platform has been demolished, while the station building lost its canopy prior to closure. Study of the photograph will reveal that the station, which was very similar to others on the Shrewsbury & Welshpool section, incorporated an L-shaped stationmaster's house and an attached waiting room, the house portion being of one-and-a-half storeys, whereas the waiting room block was just one storey. The waiting room adjoined the inner side of the 'L' in such a way that the platform frontage was entirely flush, as shown in the accompanying photograph. The building was of brick construction, with stone dressings and a slate roof.

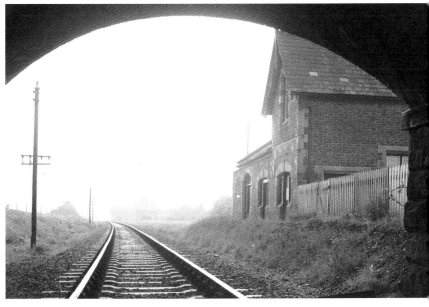

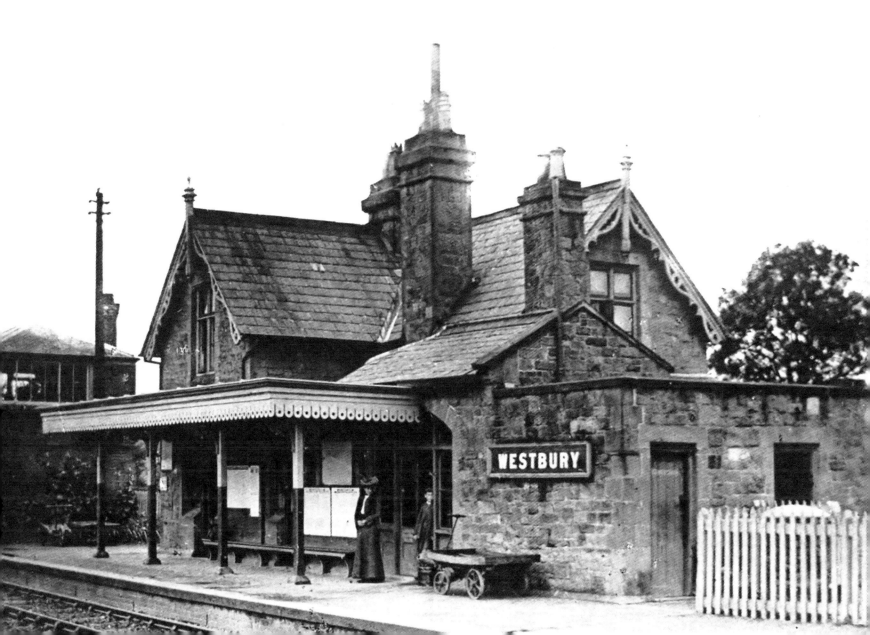

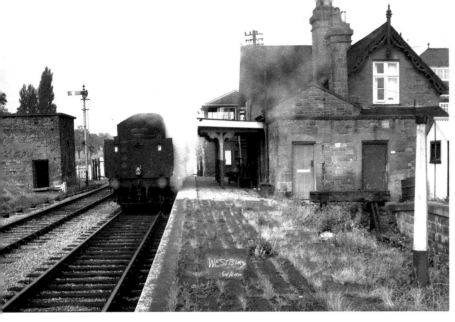

Westbury

Climbing a series of rising gradients, most of which are at 1 in 100, trains approach the site of Westbury station (11 miles), which was opened on 27 January 1862 and closed with effect from 12 September 1960 – although, goods traffic continued until March 1965 and the crossing loop was retained until the 1990s. The upper photograph, taken after the withdrawal of passenger services, shows an unidentified Class 2MT 2-6-0 alongside the up platform during the early 1960s. The main station building can be seen to the right, while the rectangular 'blockhouse' to the left of the locomotive was formerly the water tower. The A594 road crosses the line on the level immediately to the north of the now demolished platforms.

The lower view shows the existing station building, now a private house on 14 June 2003. The building is constructed of snecked stone rubble with a slated roof. As originally built, the building was a mirror image of its counterpart at Yockleton – the cross wing of the stationmaster's house being to the left when viewed from the platform. The ground-floor window and doorway have been reconstructed with horizontal lintels and modern window frames, and a glazed conservatory has been added at the east end of the building.

Previous page: Westbury

A detailed view of Westbury station during the early years of the twentieth century, showing the station building and the adjacent signal cabin. The latter structure was a hip-roofed design with small-paned windows; it dated from around 1874 and was similar to other signal boxes found on the Great Western and London & North Western joint lines around Shrewsbury. Westbury box was closed in 1988 and the level crossing is now fitted with automatic lifting half barriers.

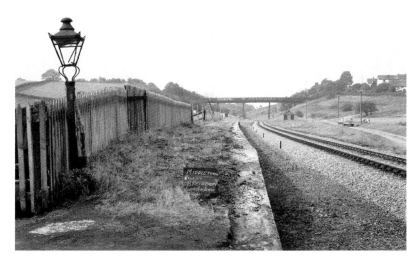

Breidden & Plas-y-Court

The Shrewsbury & Welshpool line reaches its summit around 2 miles beyond Westbury, after which westbound trains descend towards Plas-y-Court Halt (13¼ miles) and Breidden (14 miles) on falling gradients of 1 in 100 and 1 in 80. Breidden (14 miles) was opened on 27 January 1872, while Plas-y-Court was opened by the GWR on 3 November 1934. Both of these stopping places were closed with effect from 12 September 1960. Breidden station was known as 'Middletown' until 1919, and 'Middletown Hills' from 1919 until 1928, when the name was finally changed to 'Breidden'. The layout here had consisted of staggered Up and Down platforms with a small goods yard on the Up side.

Above left: A post closure of Breidden's staggered Down platform, looking west towards Welshpool around 1964.

Right: This photograph, probably taken on the same day, is looking east towards Shrewsbury, with the Down platform to the right; the Up platform was situated beyond the signal cabin. The goods siding was sited to the left of the running line.

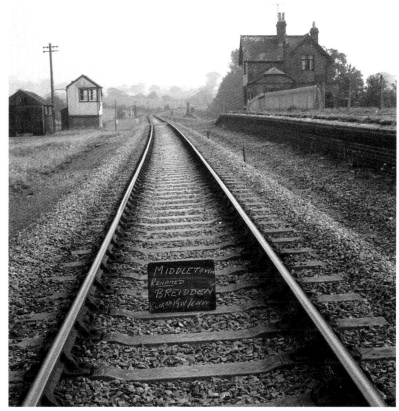

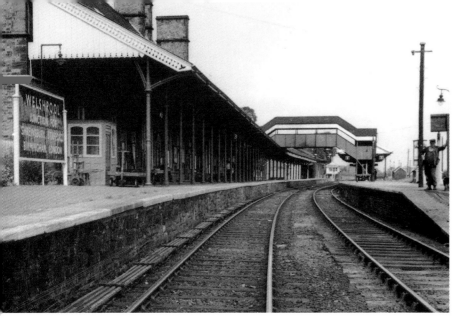

Welshpool

Continuing their descent, trains head south-westwards to Buttington (17 miles), at which point the Shrewsbury route converges with the Oswestry & Newtown line. Beyond, the route maintains its south-westerly heading towards Welshpool (33¾ miles from Whitchurch and 19¾ miles from Shrewsbury), which once boasted four platforms – the Down platform being an island with tracks on either side, while the Up platform was equipped with a north-facing terminal bay that was used mainly by local services to and from Whitchurch.

The two-storey station building, on the Up side, was a large, red-brick structure that appeared, at first glance, to be a strictly utilitarian design, the platform-facing façade being hidden behind its full-length canopy. However, the rear elevation was lavishly detailed in a sort of 'French Renaissance' architectural style, with eight gables and two prominent end towers. The two centre gables were much taller than the four outer gables, while the towers boasted steeply pitched hipped roofs with cast-iron brattishing. The windows were mullioned and transomed, and the doorways were arched in the Gothic style. A stone plaque above the main entrance was emblazoned with the Prince of Wales feathers. Examination of the canopy revealed that the ironwork was cast locally in the foundry of S. Morris of Welshpool.

Welshpool station was, at one time, signalled from two signal cabins known as Welshpool North and Welshpool South boxes, but the south box was closed in 1931, and the station was then controlled from the former north box. Both cabins were typical London & North Western style gable roofed structures with characteristic flat ended gables. The remaining signal box was closed in October 1988, and the line is now controlled by RETB from Machynlleth.

The upper view shows the station around 1962, looking east towards Shrewsbury with the former North Signal Box visible in the distance. The lower view illustrates the impressive rear façade of the main station building during the early years of the twentieth century.

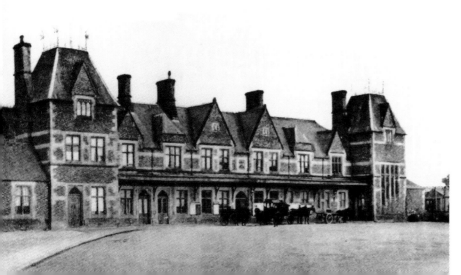

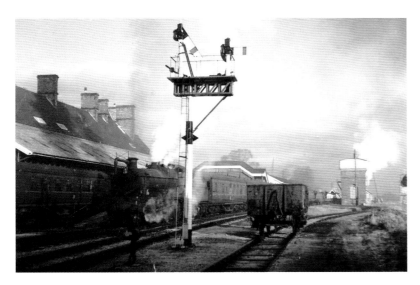

Welshpool

Above: An unidentified 63XX Class 2-6-0 stands in the Down loop platform with a westbound passenger working in February 1964.

Right: Manor Class 4-6-0 No.7819 *Hinton Manor* pauses at Welshpool with a Down express in October 1964. This engine was one of the first two Manors to appear on the Cambrian route in 1943, its companion being No. 7807 *Compton Manor*. These locomotives were soon joined by Nos 7802 *Bradley Manor*, 7803 *Barcote Manor* and 7808 *Cookham Manor*. In January 1948, the local allocation included Nos 7802 and 7803 at Aberystwyth and Nos 7807 and 7808 at Oswestry, with No. 7819 sub-shedded at Whitchurch. No. 7819 was still working on the Cambrian line in October 1965 – a month before the engine was withdrawn from service. The locomotive was saved from the scrap man, and it can now be seen on the Severn Valley Railway.

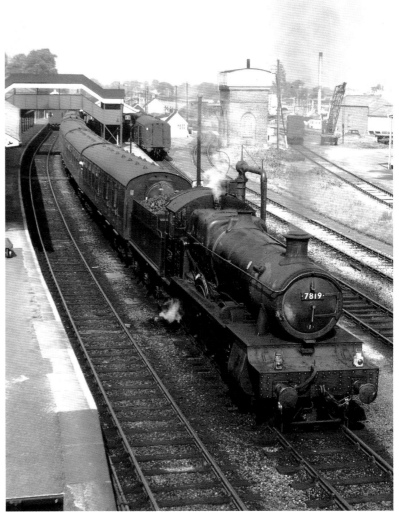

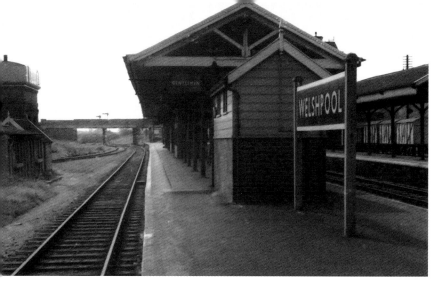

Right: Welshpool
Welshpool was formerly the 'junction' for narrow gauge services which ran westwards for a distance of 9 miles to the small market town of Llanfair Caereinion over the 2 foot 6 inch gauge Welshpool & Llanfair Railway. The W&LR was opened on 9 March 1903, all services being worked by the Cambrian Railway, while in 1923 the local company was acquired by the GWR. This Edwardian postcard scene shows Welshpool & Llanfair 0-6-0T locomotive No. 823 *The Countess* at Llanfair Caereinion. Unlike many of the other Welsh narrow gauge railways built to exploit the slate industry, the W&L line served a purely agricultural district, and its traffic was never intensive. The Great Western withdrew the passenger service in 1931, but freight traffic continued until the British Railways era.

The line was officially closed with effect from Monday 5 November 1956, the closure being marked by the running of a special passenger-carrying train on the previous Saturday. The railway was reopened as a 'heritage' line between Llanfair Caereinion and Castle Caereinion on 6 April 1963, while on 6 June 1963 the operational section was extended from Castle Caereinion to Sylfaen in 1963. A further extension took place on 18 July 1981, when the route was extended eastwards to Welshpool Raven Square. Unfortunately, it was not possible to reopen throughout to Welshpool main line station as the local council had purchased the easternmost section of the trackbed.

Left: Welshpool
This early 1960s view is looking southwards along the Down loop platform. The station was extensively reconstructed during the 1980s in connection with a road improvement scheme and, as a result, the present-day facilities consist of a single island platform which is sited to the north-east of the old Down platform. Passengers are able to reach the platform by means of a pedestrian footbridge that crosses both the railway and the new road, while the original station building survives intact on the west side of the road, having found a new role as a shop and café. The line through Welshpool has been doubled for a considerable distance – the crossing loop having been extended to a length of 2½ miles.

Welshpool –The Welshpool & Llanfair Railway

Right: The Welshpool & Llanfair Railway was worked by two 0-6-0T locomotives which were built by Beyer Peacock in 1902. In GWR days they became Nos 822 *The Earl* and 823 *The Countess*. Both of these locomotives have survived, and they both remain at work on the W&LR, although the line has, in recent years, also been operated by other interesting locomotives, including Kerr Stuart 0-6-2T No. 12 *Joan*, which had previously worked in Antigua, and Hunslett 2-6-2T No. 1, from the Sierra Leone Government Railway. The picture shows *The Countess* passing Dolarddyn with a train from Welshpool on 2 August 1987.

Below left: A detailed view of No. 822 *The Earl* taking water at Welshpool on 4 August 2002.

Below right: A further view of Welshpool & Llanfair Railway 0-6-0T No. 823 *The Countess* waiting beside the water tower at Welshpool on 4 June 2012 prior to working the 12.45 p.m. train to Llanfair Caereinion.

PASSENGERS TRAVELLING WITH GREAT WESTERN

RETURN TICKETS,

BETWEEN

LONDON

AND

THE CAMBRIAN RAILWAYS

MAY, AT THEIR OPTION, GO OR RETURN EITHER

BY THE ROYAL OXFORD ROUTE via	OR BY THE WORCESTER ROUTE. via	OR BY THE HEREFORD & GLO'STER ROUTE, via
Shrewsbury, Wolverhampton, Birmingham, Warwick, {For Stratford-on-Avon and Leam'gton,} {Kenilorth.} Banbury, Oxford and Didcot.	Shrewsbury, The Severn Valley, Worcester, Evesham, Honeybourne (for Stratford-on-Avon.) Oxford, and Didcot.	Shrewsbury, Ludlow, Leominster, Hereford, Ross, Gloucester, The Stroud Valley, and Didcot.

And Reading, Maidenhead, and Slough (for Windsor.)

Passengers Travelling between London, Windsor, Reading Basingstoke, or any place South of Basingstoke, and any of the above places, with Single or Return Tickets, may stop at Leamington or Warwick, to visit Stratford-on-Avon, and Kenilworth; and at Oxford to visit the Colleges.

Tourist Tickets are issued between certain stations on the Cambrian Railways and certain stations on the Great Western Railway, between May 1st and October 31st. For particulars see Companies' Tourist Programmes.

Cheap Excursion Tickets are issued in the Summer Months from Liverpool, Birkenhead, Manchester, Warrington, Chester, Birmingham, Wolverhampton, &c. to certain stations on the Cambrian Line, for particulars of which see Excursion Bills.

———

For Service of Through Carriages to and from the Cambrian Railways, see page 20.

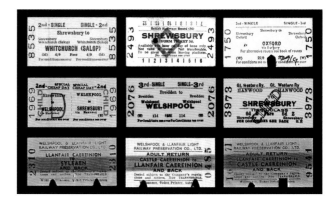

Welshpool - Tickets

Above: A selection of Edmondson card tickets from the Shrewsbury to Welshpool section of the present-day Cambrian route. The examples shown here include a platform ticket and two British Railways second class singles from Shrewsbury, together with BR and GWR tickets from Hanwood, Breidden and Welshpool, and three tickets from the narrow gauge Welshpool & Llanfair Railway. British Railways second and third class tickets were normally light green, while Great Western 'child' tickets were printed on sky-blue cards – it should be noted that third class was officially replaced by 'second class' on Sunday 3 June 1956, although there was no difference in the accommodation provided or the fares that were charged! The colourful Welshpool & Llanfair tickets were issued after the reopening of the railway as a 'heritage' line in 1963; in earlier days, the W&LR had been regarded as a normal GWR branch, and standard Great Western tickets had been used.

Left: This extract is taken from a Victorian publicity booklet issued around 1885 and it provides details of the summer 'tourist' tickets that were available at that time between certain stations on the GWR and selected stations on the Cambrian system; passengers in possession of these special through tickets were allowed to break their journeys at Oxford, Kenilworth and Warwick (for Stratford-upon-Avon). Cheap excursion tickets were also available during the summer months from Liverpool, Manchester, Birmingham and other major centres of population.

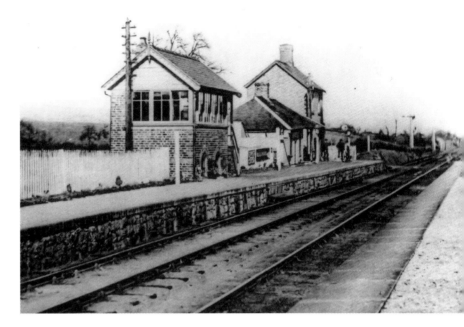

Forden

Having left Welshpool, trains head due south along the Severn Valley towards the now closed stopping place at Forden (24¼ miles), which was opened by the Oswestry & Newtown Railway on 10 June 1861 and closed with effect from 14 June 1965. Up and Down platforms were provided here, the main station building being on the Up side, while the modest goods yard was sited behind the Down platform; a minor road crossed the line on the level at the north end of the platforms. In architectural terms, the main building was a squat, hip-roofed structure with a recessed loggia (or waiting area) for intending travellers. This small structure was flanked by two other buildings – a two-storey stationmaster's dwelling house sited immediately to the north, while the standard Cambrian signal box was situated to the south. The latter structure was a gable-roofed cabin with a twenty-two-lever frame.

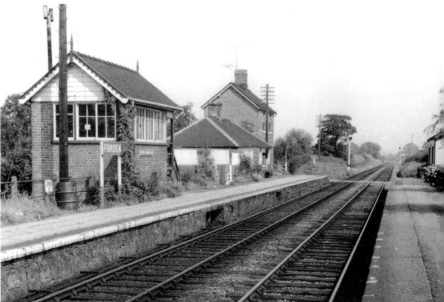

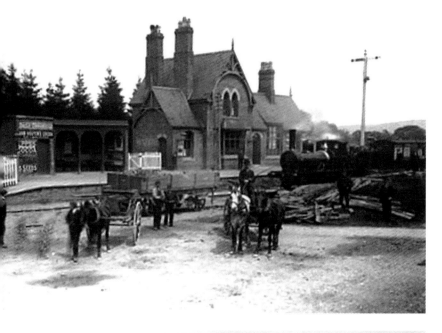

Montgomery

From Forden, the railway continues southwards for a little over a mile before turning onto a south-westerly heading on the approaches to Montgomery (26 miles), a crossing place with slightly staggered Up and Down platforms. This station was opened on 10 June 1861, although the imposing brick-built station building was added during the early 1870s. In February 1872, the Cambrian directors reported that 'a permanent station' had been erected at Montgomery – the implication being that the original station had been merely a temporary structure.

The upper picture provides a glimpse of the station during the Victorian period, while the two lower views date from the 1960s. The station building, on the Up platform, incorporates a single-storey waiting room block and a two-storey stationmaster's house, the domestic block being arranged as a cross wing with a platform-facing gable. The steeply pitched roof line imparts a distinct Gothic atmosphere, the medieval theme being further emphasised by the provision of pointed upper floor windows. The main goods yard, visible beyond the level crossing, contained a goods shed and coal wharves, while additional goods facilities were available on the Up side, including cattle loading pens and a 6-ton yard crane. The signal box was a brick-and-timber structure with a gable roof and a thirty-lever frame.

Opposite: Montgomery

A general view of Montgomery station during the British Railways period, around 1962. Sadly, passenger services were withdrawn from this station with effect from 14 June 1965, and the signal box was closed in 1969.

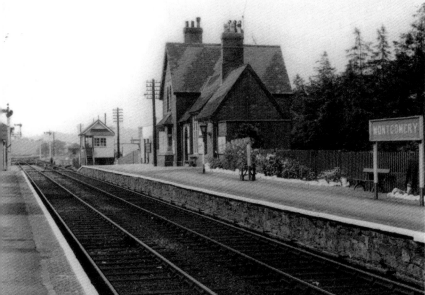

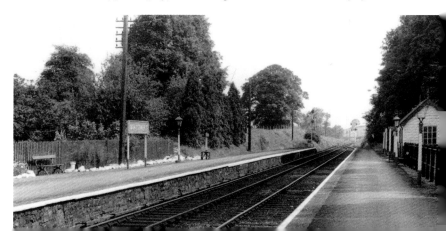

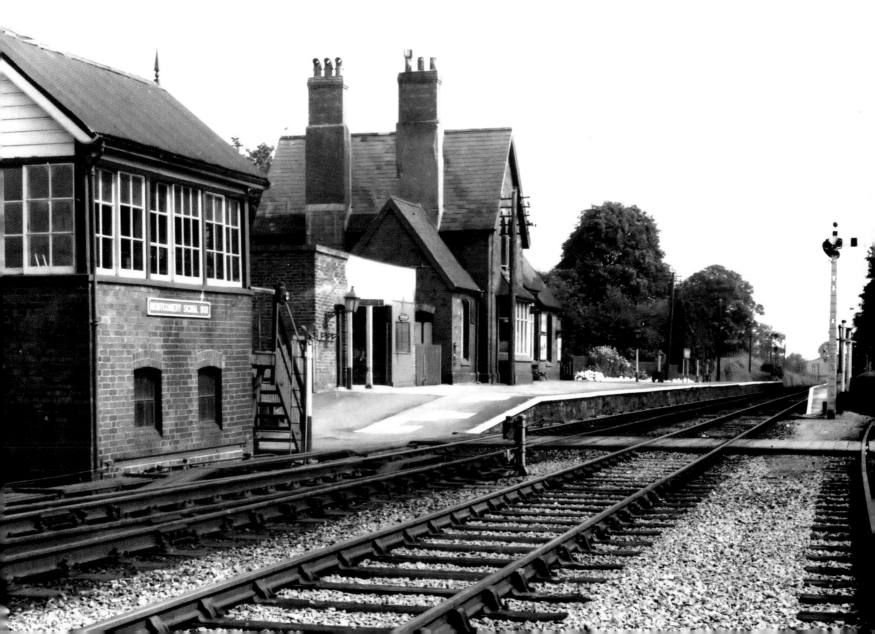

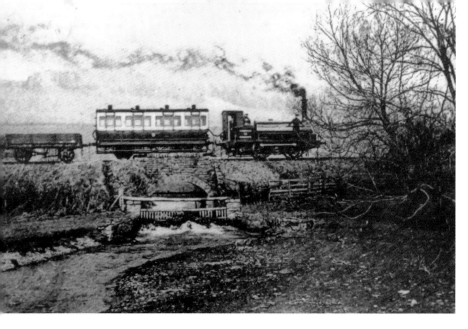

Abermule

Abermule station (29¾ miles) was opened on 14 August 1860 and closed with effect from 14 July 1965. The station was a crossing place with Up and Down platforms for main line traffic and an additional platform face for Kerry branch services. The station building and goods yard were on the Up side, and a minor road crossed the line on the level at the north end of the platforms.

The Kerry branch, which diverged on the Down side, was authorised by the Oswestry & Newtown Act of 1861 and opened for goods on 2 March 1863 and for passengers just one month later. This sharply curved and heavily graded line was single track throughout, and it followed the River Mule to its terminus in the small town of Kerry, a distance of 3 miles and fifty-five chains. Passenger services were withdrawn in February 1931, though freight traffic was carried for another twenty-five years before final closure took place with effect from 1 May 1956. The upper photograph depicts a Kerry branch train during the early 1900s.

Abermule is remembered as the setting for the Cambrian's worst disaster. On 26 January 1921 a series of operational errors resulted in the driver of the 10.05 a.m. stopping train from Whitchurch being handed the wrong electric tablet which, in turn, resulted in a head-on collision between the local train and the Aberystwyth to Manchester express, headed by Cambrian 4-4-0 locomotive No. 95. Fifteen passengers were killed in the ensuing collision, including Lord Herbert Vane-Tempest, a director of Cambrian Railways. The crew of the local train were also killed, but the driver and fireman of the much heavier express locomotive survived the accident, and were able to explain that, although they had made a full emergency brake application, the crew of the local train had made no attempt to slow down – presumably because they had not seen the oncoming express. The lower view shows the aftermath of the collision; the frames of the express locomotive have reared into the air above the telescoped coaches.

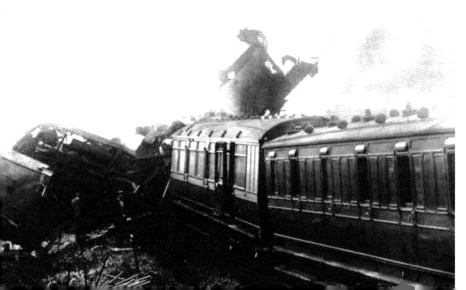

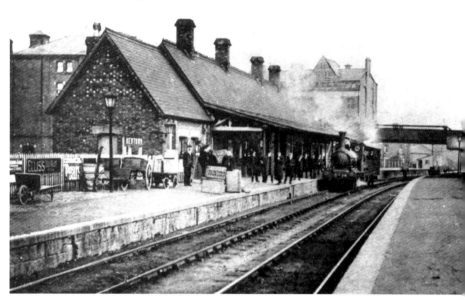

Newtown

With the A483 road running parallel to the left and the Montgomery Canal maintaining a similar course to the right, the railway follows the upper Severn Valley to Newtown (33½ miles). When opened on 31 August 1859, the Llanidloes & Newtown Railway had terminated in a temporary station on the west side of the town, but this was replaced by a 'joint' station when the Oswestry & Newtown Railway was completed on 10 June 1861. The facilities provided were, at first, rather primitive, but in November 1868 the Cambrian began work on a much improved station, which was completed in May 1869.

The new station had Up and Down platforms with a loading dock on the Up side and an additional bay on the Down side. The main station building, on the Up platform, was a red-brick structure with a lengthy canopy and a steeply pitched gable roof. The rear elevation was featured gabled bays at each end and a centrally placed porch. The roof line was enlivened by the provision of crested ridge tiles and four brick chimney stacks. The upper photograph shows the station building at the end of the Victorian period. Internally, this extensive structure contained a range of accommodation including (from left to right) a parcels office; ladies' room; stationmaster's office; booking office; booking hall; a ticket collectors' room; the general waiting room and a porters' room. The Up and Down platforms were linked by a lattice girder footbridge, while the Down platform was equipped with an open-fronted waiting shelter.

The lower view is looking east towards Shrewsbury during the early 1960s; the Down bay platform can be seen to the right, while the large Victorian building in the background housed a pioneering mail-order business that had been established by Sir Pryce Pryce-Jones (1834–1920) during the 1860s. The Pryce-Jones building was taken over by the Admiralty during the Second World War, and it later became part of Great Universal Stores. Newtown retains full ticket issuing facilities, and the station building also houses a restaurant (Station Grill) and a computer training centre.

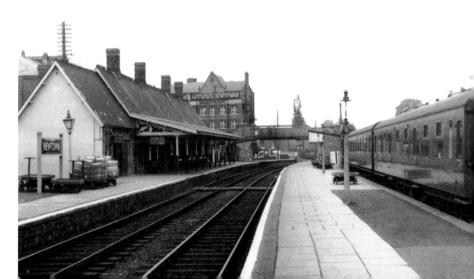

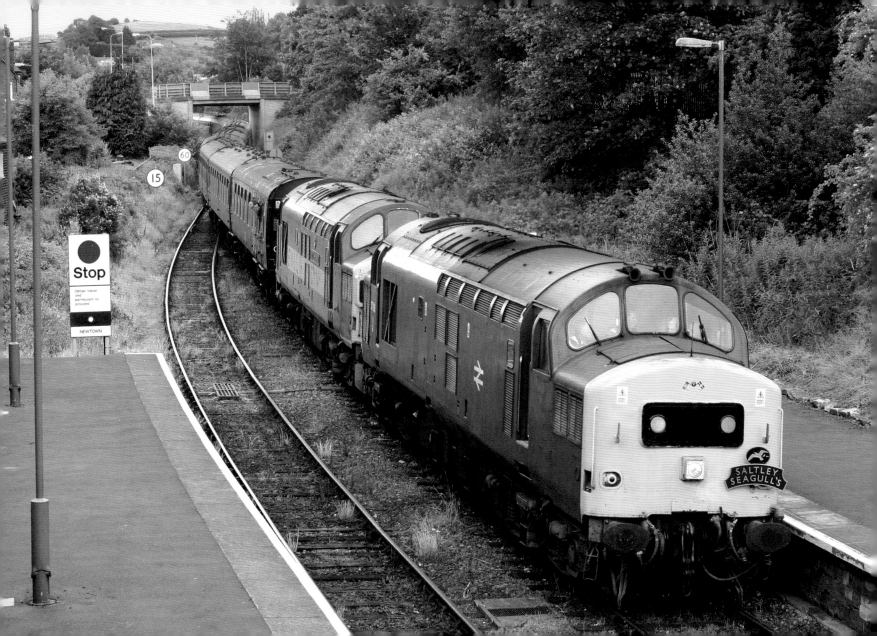

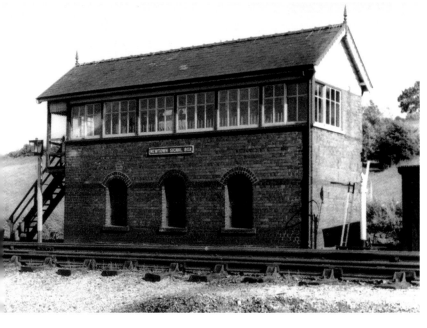

Left: Newtown – The Signal Box

The standard Cambrian Railways gable-roofed signal box was built by Dutton & Co. in 1894. It was situated to the west of the platforms on the down side, and was formerly known as Newtown South to distinguish it from another box known as Newtown North Box which had only eight levers, and was closed in 1920. The former south box had originally contained a fifty-four-lever frame, but this was later replaced by a Great Western tappet frame with thirty-five levers. Newtown Signal Box was closed in 1988, when the final stage of the Cambrian RETB re-signalling scheme was brought into use.

Right: Scafell Halt

Resuming their journey, down trains head west-south-west along the Severn Valley towards the long closed station at Scafell. This obscure stopping place had a chequered history, having been opened in 1863 and closed in July 1891. The station reopened in July 1913, by which time the section of line between Newtown and Moat Lane had been doubled; however Scafell remained a single-platform station, which meant that it was served only by Up trains! Through tickets were no longer issued, and travellers wishing to alight at Scafell were asked to re-book at Moat Lane. Passenger services were withdrawn for a second time in 1952, although goods trains continued to call until 1955.

Opposite: Newtown

Class 37 locomotives Nos 37308 and 37114 *City of Worcester* arrive at Newtown with the 8.32 a.m. Saltley Welfare Fund Birmingham International to Aberystwyth railtour on 19 June 2004.

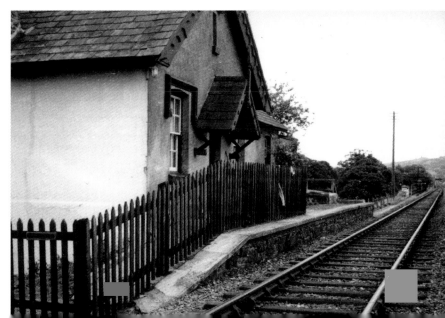

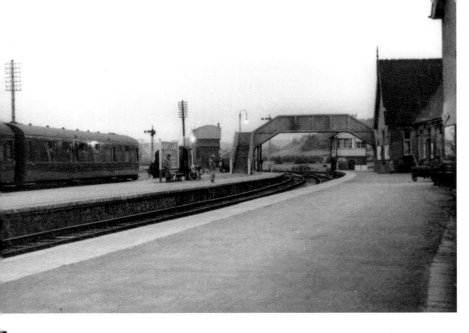

Moat Lane Junction

Heading first north-westwards and then south-westwards, the route meanders up the Severn valley towards Moat Lane Junction (38¼ miles), which was opened by the Llanidloes & Newtown Railway on 2 September 1859 and closed with effect from 31 December 1962. The section of line between Newtown and Moat Lane junction was doubled in 1912, although this 4¾ mile section has now reverted to single track.

Moat Lane, the junction for Mid-Wales services, was another 'triangular' station, its track layout being similar to Buttington's, insofar as the platforms were situated at the 'V' of the junction. The upper view is looking eastwards along the main line platforms around 1963, the Down platform being visible to the right, while the Up main line platform can be seen to the left of the picture. The Up platform had an east-facing bay.

The lower view shows GWR Dean Goods 0-6-0 No. 2468 alongside the Mid-Wales platform around 1930. The Mid-Wales side of the station had just one platform, together with an engine-release road; it was laid out on a diverging alignment in relation to the Down main line platform – the two platforms being sited within the 'V' of the junction. Although Moat Lane was primarily an interchange point between the Cambrian main line and the Mid-Wales route, it had a small goods yard that was able to handle wagonload traffic and general merchandise, together with an engine shed that normally housed around half-a-dozen locomotives. In January 1948, the local allocation comprised Dean Goods 0-6-0s Nos 2354, 2449 and 2482; 2021 Class pannier tank No. 2069; and former Cambrian 0-6-0 No. 844. The two-road shed building was rebuilt in 1957. It measured approximately 70 feet by 35 feet at ground level and remained in use until December 1962.

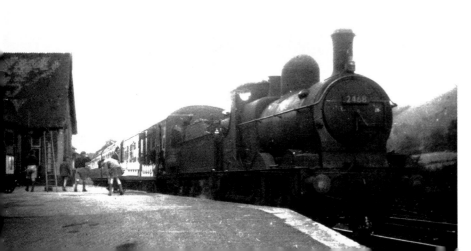

Above: Moat Lane Junction

Ivatt Class 2MT 2-6-0 No. 46526 awaits its next turn of duty outside Moat Lane shed. Ex-LMS and British Railways standard Class 2MT 2-6-0s appeared on the Cambrian system after the line was transferred to the London Midland Region, although Manor 4-6-0s and other Great Western classes continued to appear on the line.

Below: Caersws

Turning onto a north-westerly direction, heading trains soon reach the next station at Caersws (39¼ miles). Opened by the Newtown & Montgomery railway on 3 January 1863, this was formerly a crossing station, but it was not suitable for crossing two passenger trains as there was just one platform, on the Up side. When it was necessary for two passenger trains to pass, the normal procedure would be for the Down train to enter the loop and be brought to a stand. The Up train would then be allowed into the station, and when it had been dealt with the Down train would reverse out of the loop and draw forward into the platform. On departure, the Down train would reverse out of the platform and run through the loop – this manoeuvre being necessary because of track circuiting.

The station building is of typical Cambrian Railways design, with a single-storey waiting room and a two-storey stationmaster's house at the west end. The photograph is looking eastwards around 1963, the goods shed being visible beyond the level crossing; the loop has now been removed and the crossing gates have been replaced by automatic lifting half-barriers.

Caersws was once the junction for the Van Railway, which served the lead mines at nearby Van, and opened for freight traffic on 14 August 1871. Passengers were carried from 1873 until 1879 – the Van Railway having its own small station in the goods yard at Caersws. The railway was closed in its entirety between 1893 and 1896, though revival, of a kind, came in 1896, when this obscure line was reopened for ballast traffic. Final closure took place in 1941, apart from a short section of track at Caersws, which was used by bridge department engineers until 1984. Caersws is associated with the Welsh poet John 'Ceiriog' Hughes (1832–87), who became general manager of the Van Railway in 1872 after serving as stationmaster at Tywyn.

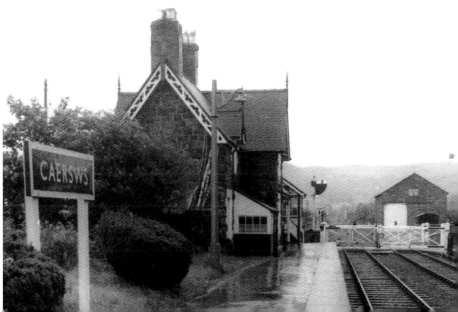

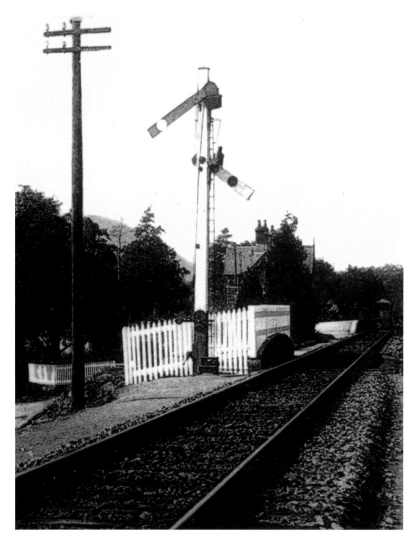

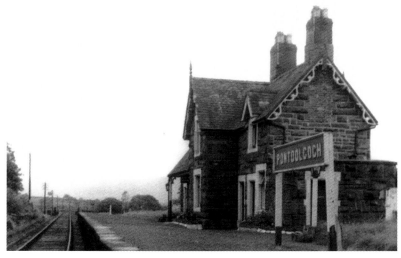

Pontdolgoch

Above: Having left the Severn Valley at Caersws, Down trains are faced with 8 miles of rising gradients, including half-a-mile at 1 in 71 near Pontdolgoch station. Opened by the Newtown & Machynlleth Railway on 3 January 1863, this now closed stopping place was 41 miles from Shrewsbury. It was similar to the other wayside stations on the Cambrian route, with a small goods yard and a substantially built stone station building – the latter structure being a mirror image of that at Caersws, with its two-storey house portion to the right of a single-storey waiting room (when viewed from the platform). The building was of snecked stone construction, with a slate roof, ornate barge boards and tall chimney stacks. The front of the waiting room was recessed beneath the gable roof to form a covered waiting area. The station was closed with effect from 14 June 1965.

Left: Taken from an Edwardian colour-tinted postcard, this *c.* 1908 view shows a Cambrian Railways semaphore signal with two arms on the same post. Cambrian signals had noticeably slender signal arms, the red home and starting arms having a white circle on the front and a black circle on the rear.

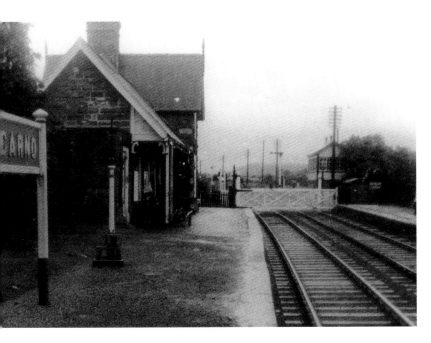

Left: **Carno**

Climbing steadily, the railway continues north-westwards to Carno (45¼ miles) which, like the other intermediate stopping places on this section of the line, was ceremonially opened on 3 January 1863. Carno was a crossing station with Up and Down platforms, the main station building being on the Down side, while a minor road crossed the line immediately to the west of the platforms. The photograph is looking westwards along the down platform, with the station building to the left and the signal cabin visible beyond the level crossing. The station building is of the usual Cambrian design, buildings of the same general type being found on all of the constituents of the Cambrian Railways system – suggesting a degree of collusion between the promoters of nominally independent companies such as the Oswestry & Newtown and Newtown & Machynlleth railways.

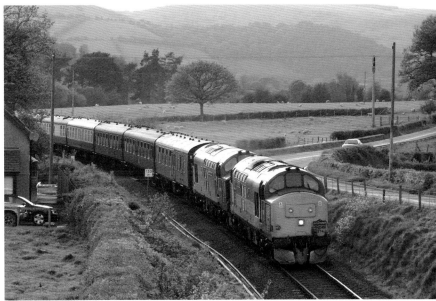

Right: **Carno**

Class 37 locomotive No. 37417 *Richard Trevithick* was left at Machynlleth on the outward leg of the Pathfinder Tours 'Snowdonian' railtour on 20 May 2006 because, at that time, only a single locomotive was allowed over the Barmouth Bridge. The locomotive is seen here running parallel to the main A470 road at Carno at the head of the 4.22 p.m. from Pwllheli in conjunction with sister engine No. 37411 *Caerphilly Castle* – this being the return leg of the railtour. Carno station was closed with effect from 14 June 1965 and the building then became part of the adjacent Laura Ashley site. The latter facility was itself closed in 2004, and campaigners have been trying for several years to get the station reopened, possibly as part of an information centre and Laura Ashley design museum when the redundant industrial site is redeveloped.

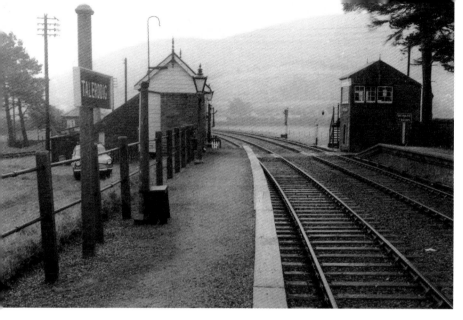

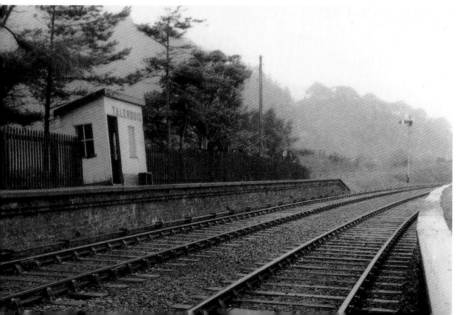

Talerddig

From Carno, the railway climbs towards Talerddig Summit, around 693 feet above mean sea level, on a rising gradient of 1 in 80. Talerddig station (47¼ miles), was opened by the Cambrian Railways in 1900 and closed with effect from 14 June 1965. The layout here included a crossing loop that was long enough to accommodate trains of ten bogie coaches, and there was also a small goods yard. The accompanying photographs show Talerddig station during the early 1960s. The signal cabin that can be seen in the upper view was built by McKenzie & Holland of Worcester in 1874, although various modifications were made to it over the years, including the replacement of the original hipped roof. In recent years, the box was equipped with an eighteen-lever tappet frame. The box was taken out of use in connection with the introduction of the RETB signalling system in 1988, although the crossing loop was retained.

In steam days, heavy eastbound trains had required banking assistance on the climb to Talerddig Summit, the usual procedure being for banking engines to be attached to the front of Up passenger workings, whereas freight trains were normally banked in the rear to obviate the danger of breakaways. Westbound service did not normally require banking assistance, although on Saturdays in the summer, the heavily loaded Cambrian Coast Express was often hauled by two locomotives between Welshpool and Machynlleth, where the train would be divided into separate Aberystwyth and Pwllheli portions. Under normal circumstances, Manor Class 4-6-0s and 63XX Class 2-6-0s were able to take eight or nine coaches up the incline without assistance.

Opposite: Talerddig

Class 20 locomotives Nos 20313 and 20314 approach Talerddig Summit at the head of the Eagle Railtours Aberystwyth to Leamington Spa 'Cambrian Mountain Explorer' railtour on 16 May 1999. The tour participants had earlier enjoyed a ride on the narrow gauge Vale of Rheidol Railway.

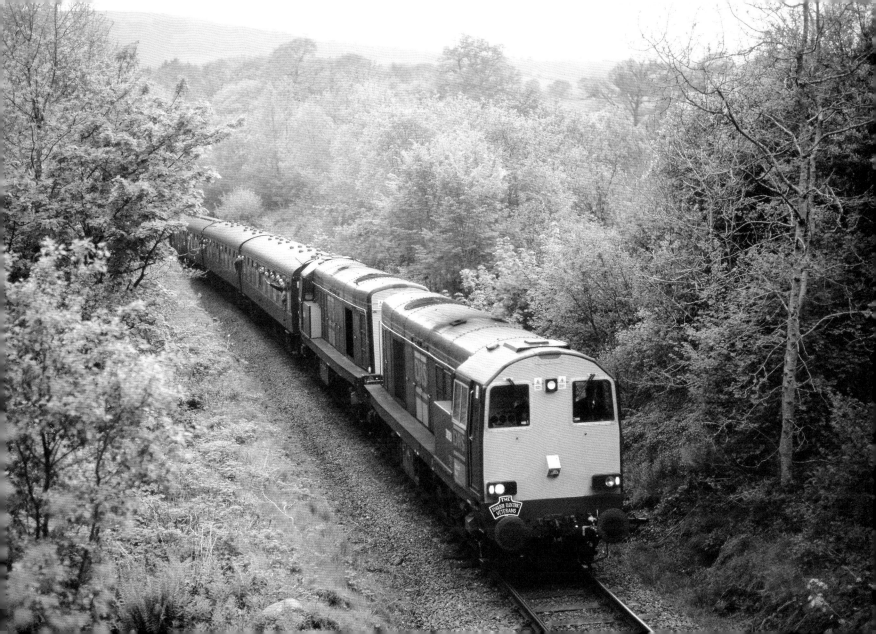

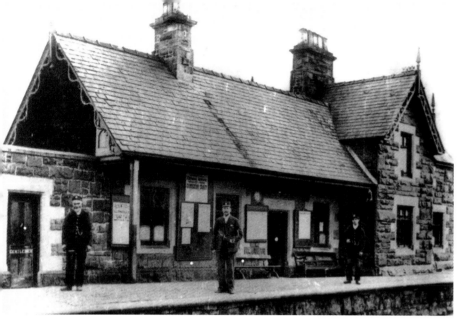

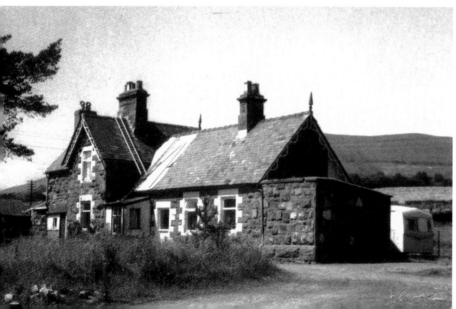

Llanbrynmair

Having surmounted the formidable Talerddig incline, Down trains drop towards the Dovey valley on a succession of sharply falling gradients, the steepest of which include 2 miles of 1 in 52 and a mile of 1 in 56. Llanbrynmair (50¾ miles), the next station, was opened on 3 January 1863 and closed with effect from 14 June 1965.

Llanbrynmair was a typical Cambrian station, with a substantial station building of the now familiar type. This characteristic structure, now a private dwelling, incorporates a single-storey waiting room block and a two-storey stationmaster's house, the domestic portion being to the right of the waiting room when viewed from the platform. The building is of snecked stone construction with a slate roof and ornate barge boards with finials and pendants. As usual on this type of building, the front of the waiting room is set back to form a covered loggia for intending travellers. These features can be clearly seen in the upper photograph, which shows Llanbrynmair station during the Edwardian era, around 1909. The lower picture shows the rear of the station building after closure; the projecting wing on the extreme right houses the gentlemen's urinals.

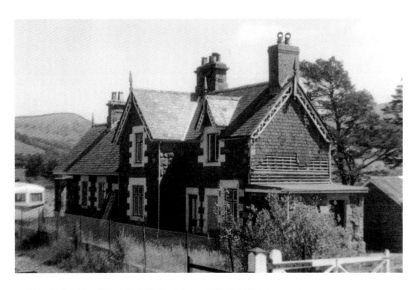

Llanbrynmair

Right: A view of the station building from the west, showing the stationmaster's house in greater detail; the decorative barge boards and ornamental finials can be clearly seen; the chimneys, two of which are of stone while one is of brick construction, have yellow terracotta pots.

Below left: A detailed view of the goods shed, which was of snecked stonework, with a gable roof.

Below right: The weigh house is built of brickwork – the corrugated iron cladding that has been applied at one end was presumably added to provide additional weatherproofing. These post-closure photographs were taken by Mike Marr.

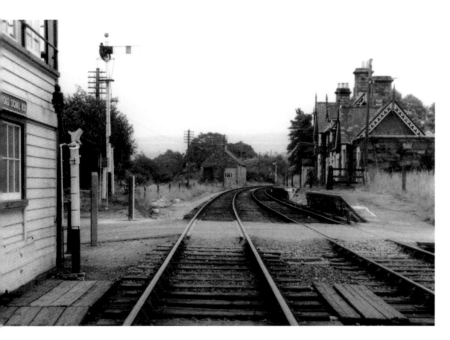

Right: **Cemmes Road – The Mawddwy Railway**

The Mawddwy Railway was opened from Cemmes Road to Dinas Mawddwy on 30 September 1867. The line was worked by two Manning Wardle 0-6-0STs named *Mawddwy* and *Disraeli*, and services originally ran to and from a separate Mawddwy Railway station at Cemmes Road. The railway was closed in April 1901 and reopened as a light railway on 31 July 1911. In 1925, the line was served by five trains each, all services being 'mixed' formations that conveyed both passenger vehicles and goods wagons; in that same year, the railway carried 4,707 tons of freight, the principal forms of traffic being slate, pit-props and coal. Passenger services were withdrawn for a second time with effect from 1 January 1933. The photograph shows the terminus at Dinas Mawddwy, which boasted a pair of incongruous iron gates, supported by two ornamental gateposts.

Left: **Cemmes Road**

Still descending, trains pass the site of Commins Coch Halt (54¼ miles), opened by the GWR on 19 October 1931, and closed with effect from 14 June 1965. Cemmes Road (56 miles), was the junction for branch service to Dinas Mawddwy. This station was opened with the line on 3 January 1863, and its infrastructure included a typical Cambrian station building, together with coal wharves, a goods yard, cattle-loading pens and a signal box. The station building, now a private house, was of typical Cambrian Railways design, with a single-storey waiting room and an attached two-storey stationmaster's house at the east end. The building is of the usual snecked stone construction with a slate roof, ornate barge boards and tall chimney stacks. Sadly, this station was closed as part of the purge of wayside station that took place with effect from 14 June 1965.

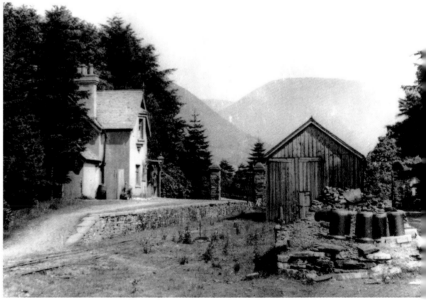

Machynlleth

Machynlleth (61 miles) is in many ways the operational centre of the present-day Cambrian line. Opened on 3 January 1863, the station has staggered Up and Down platforms – the Down platform being sited slightly further to the west than its counterpart on the Up side. The Up and Down sides of the station are linked by a lattice girder footbridge, while Doll Street passes beneath the line at the Aberystwyth end of the Down platform. The main station building, on the Down side, is an impressive, two-storey structure with a steeply pitched gable roof and three prominent gables on each façade – the platform frontage being partially hidden by a full-length canopy, while the rear elevation features three projecting wings.

Prior to rationalisation, the infrastructure provided at Machynlleth had been relatively complex, with a goods yard and locomotive depot on the down side and additional sidings, known as the 'Lower Yard', on the up side of the running lines. The station site is overshadowed on the down side by a sheer rock face, and perhaps for this reason the locomotive facilities and the goods sidings were crammed into a long narrow site – the cattle-loading pens being served by a siding that branched out from the locomotive yard. The Down side sidings were sometimes referred to as the 'upper yard' to distinguish them from the low level sidings on the Up side. There was a large goods shed in the upper yard, together with a plethora of sheds, storage buildings and permanent way huts, while the engine shed was a three-road gable-roofed structure with a two-road extension at its east end, the overall dimensions of the building being around 200 feet by 50 feet. The shed was coded 89C from 1948 until 1963, and 6F from 1963.

The upper picture, dating from around 1908, shows Cambrian Railways 2-4-0 No. 43 alongside the impressive station building, while the lower view, from an Edwardian postcard, shows the rear of this E-shaped structure, with its three prominent gabled cross wings.

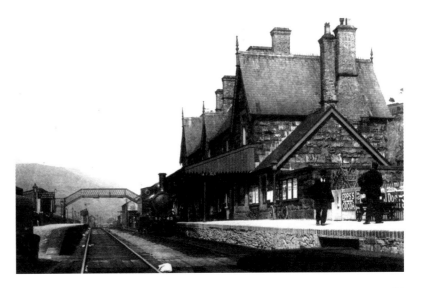

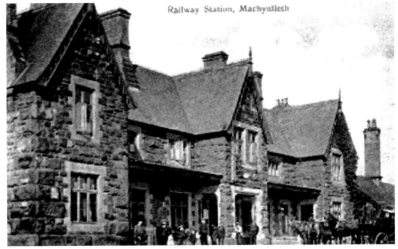

Railway Station, Machynlleth

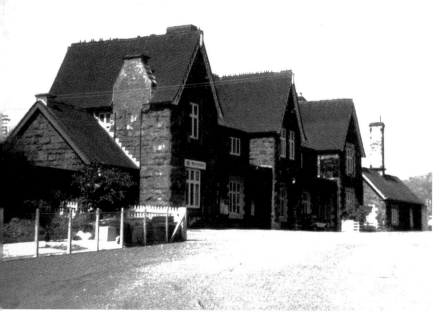

Machynlleth

Left: By the 1980s, the station building had lost its chimney stacks and most of its crested ridge tiles, though in the event these features were subsequently restored. The stone used for the construction of this building is said to have been excavated from the summit cutting at Talerddig.

Below left: A detailed view of the Down side waiting room during the 1980s.

Below right: The weigh house was sited in the lower yard, at the rear of the Down platform; these three photographs were taken by Mike Marr.

Opposite: Machynlleth

A recent photograph of the main station building taken on 19 October 2014. This distinctive building is still in use, and it has retained its booking office and waiting room facilities. The chimneys and other features have been fully restored.

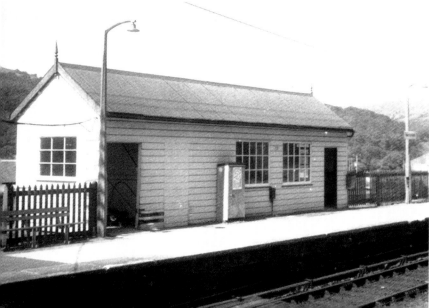

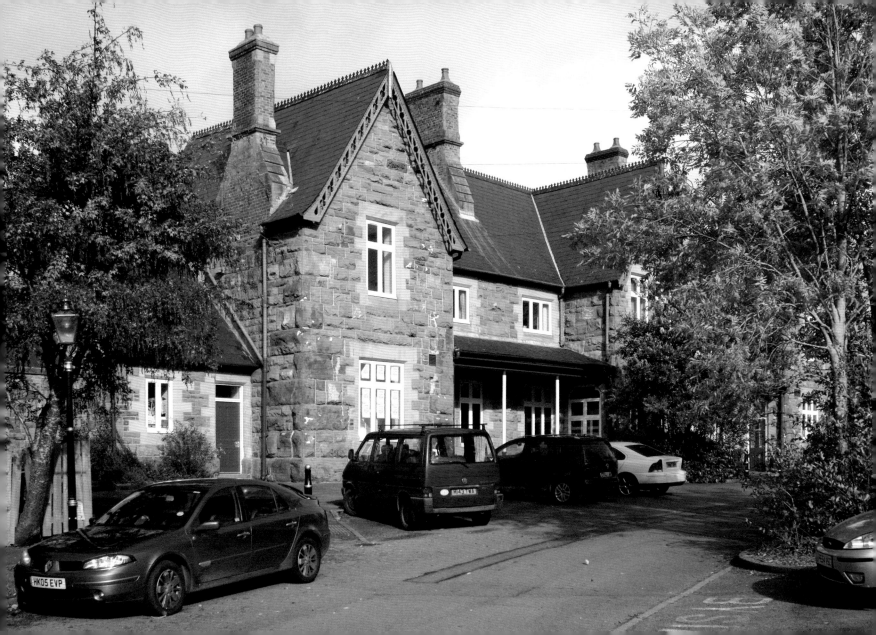

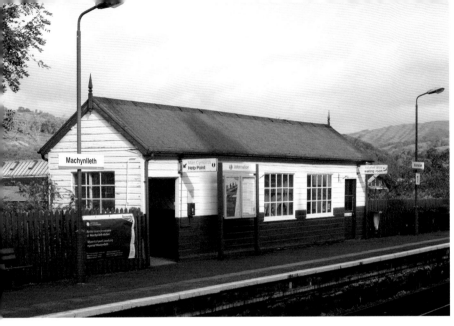

Above: Machynlleth

The wooden station building on the down side has been retained, and it now looks smart in a green-and-white colour scheme, as depicted in this recent photograph taken on 19 October 2014. Cambrian Railways passenger vehicles had been painted in a very similar green-and-white livery.

Below: Machynlleth

A detailed view of the lattice girder footbridge, which presumably dates from Cambrian Railways days. A bus stop style shelter has been erected on the Up platform, in addition to the wooden building seen in the previous photograph.

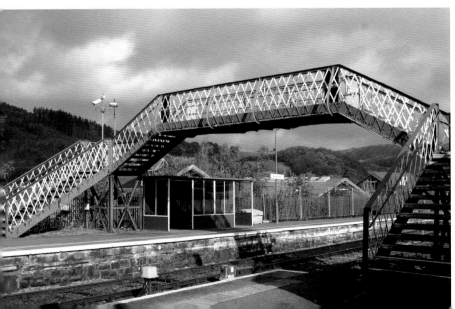

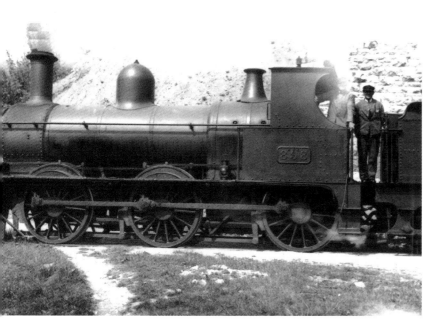

Right: Machynlleth – Passing the Engine Shed

Class 158 unit No. 158841 arrives at Machynlleth with the 11.26 a.m. Shrewsbury to Aberystwyth Arriva Trains Wales service on 19 October 2014. The two-car unit is passing classmate No. 158839, which is resting between duties in the former steam locomotive shed. The locomotive depot was closed in 1966, and most of its buildings were then demolished. However, the walls of the original shed survived, and the building is now back in use, albeit with a new roof. The depot now serves as the main base for the fleet of Class 158 diesel multiple units used by Arriva Trains Wales to operate the Cambrian Line. The signal box was sited just beyond the Up platform, on the extreme left of the picture, but the traditional box has now been replaced by a new control centre that has been built on the opposite side of the line. The Cambrian Line signalling has been centrally controlled from Machynlleth since the 1980s, when traditional signalling was replaced by the RETB system.

Left: Machynlleth – Outside the Engine Shed

Cambrian Railways 0-6-0 No. 14, built by Sharp Stewart in 1875 (Works No. 2511) became GWR No. 898 after the grouping. This locomotive was originally built for the Furness Railway, but it was never delivered, and was purchased instead by the Cambrian Railways in 1878; the engine is pictured outside the shed at Machynlleth around 1930. In 1948, Machynlleth had an allocation of twenty-four locomotives, including ten 'Dukedog' 4-4-0s; seven 'small prairie' 2-6-2Ts; three tank locomotives; two Dean Goods 0-6-0s; one 2251 Class 0-6-0; and veteran Cambrian 0-6-0 No. 864.

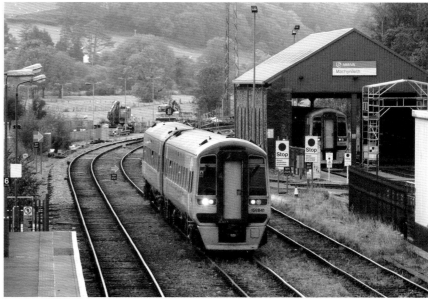

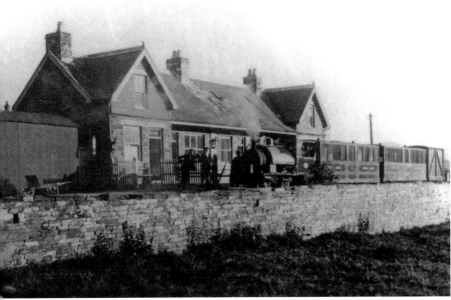

Machynlleth – The Corris Railway

Machynlleth was the junction for the 2 foot 3 inch gauge Corris Railway, which was incorporated by Act of Parliament on 12 July 1858 as 'The Corris, Machynlleth & River Dovey Tramroad'. The line, which served quarries in and around Corris, was opened in April 1859, and, as originally constructed, the route extended northwards from Derwenlas to Machynlleth and thence along the Afon Dulas valley to Aberllefenni. When opened in January 1863, the Newtown & Machynlleth Railway severed the narrow gauge line at Machynlleth, and the section of line between Machynlleth and Derwenlas was abandoned. The tramway was originally worked by horses and gravity – loaded slate wagons ran downhill to Machynlleth, where the slate was transhipped into standard gauge wagons.

In 1878 the line was acquired by the Imperial Tramways Co. of Bristol and, following this change of ownership, steam power was introduced in February 1879. Passenger services had been in operation since 1874, but a steam-worked passenger service was brought into use on 4 July 1883, by which time the name of the undertaking had been changed to 'The Corris Railway'. The upper photograph shows a passenger train in the Corris Railway station at Machynlleth *c.* 1910, the locomotive being No. 2, while the lower view shows a freight train crossing the Dovey Bridge behind locomotive No. 4. The passenger station was situated in the lower yard, and the Dovey Bridge was a short distance to the north of the station; it was reconstructed in 1906, the original bridge having been a timber trestle structure.

The Corris Railway was purchased by the GWR in 1930, but passenger services were withdrawn with effect from 1 January 1931. The last freight train ran in 1948 after heavy flooding had damaged the line, and the two surviving Corris Railway locomotives were acquired by the Talyllyn Railway in 1951. A short section of the Corris Railway was reopened in 2002 and the line now functions as a heritage railway.

Opposite: Machynlleth

Class 158 unit No. 158836 heads away from Machynlleth station with the 11.30 a.m. Aberystwyth to Birmingham International Arriva Trains Wales service on 19 October 2014.

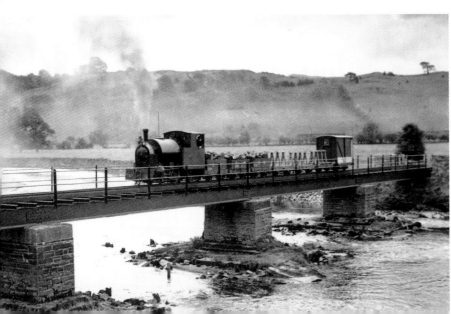

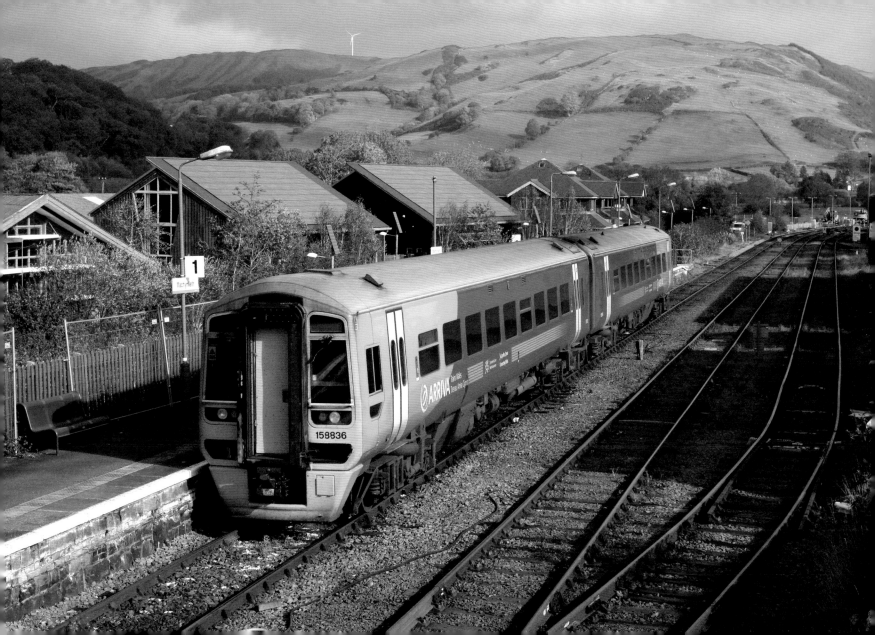

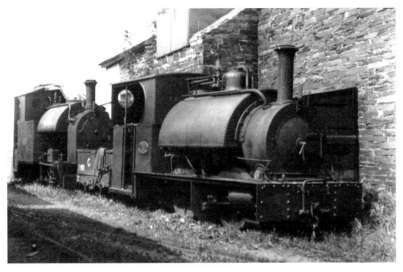

Machynlleth – Corris Railway Scenes–

Left: Corris Railway 0-4-2ST locomotives Nos 3 and 4, which became *Sir Haydn* and *Edward Thomas* respectively after they had been sold to the Talyllyn Railway. The Corris line was originally worked by three 0-4-0 saddle tank locomotives, but all three were subsequently rebuilt as 0-4-2STs; Nos 1 and 2 were withdrawn in 1930.

Below left: A detailed study of Corris 0-4-2ST No. 4 at Machynlleth around 1934. This engine was built by Kerr Stuart and acquired by the Corris railway in 1921.

Below right: Corris 0-4-2ST No. 3 *Sir Haydn* returned home to the Corris Railway on 3 June 2012. Although unable to run as its boiler certificate had expired, the veteran Corris locomotive was a star attraction on the line, which it left in 1951 for a second life on the Talyllyn Railway. The locomotive is pictured standing beside the reconstructed Maespoeth Junction Signal Box.

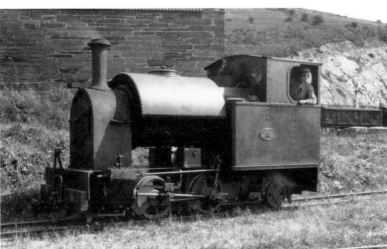

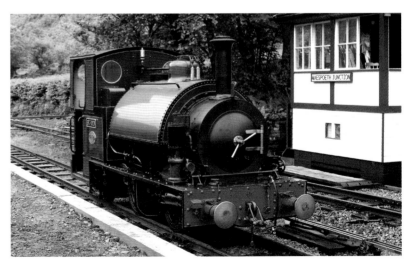

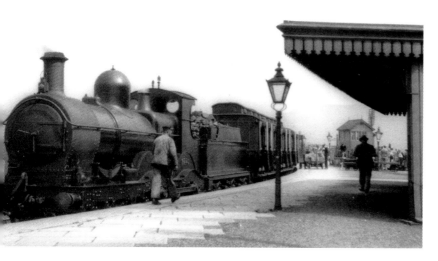

Right: Great Western 63XX Class 2-6-0 No. 6395 stands alongside the Pwllheli platform during the early 1960s. The flat-roofed building that can be seen beyond the name board was a sixty-five-lever signal box that replaced the earlier cabin in 1959. It remained in use until the introduction of RETB block signalling in 1988. The prefabricated building to the right of the signal box was a new booking office, erected in 1956.

Dovey Junction

Left: Dovey Junction (65 miles), a curiously isolated station with no road access, marks the point at which the Pwllheli line diverges from the Aberystwyth route. This passenger-only stopping place was opened on 14 August 1867 and it was, for a time, known as 'Glandovey Junction'. The platform arrangements here echoed those at Buttington and Moat Lane – the station having a triangular track layout, with diverging platforms for the Pwllheli and Aberystwyth lines. The photograph shows an unidentified GWR Barnum Class 2-4-0 alongside the Pwllheli platform, probably during the mid-1920s. The station building and signal cabin can be seen to the right of the picture; the station building, which contained a refreshment room for the benefit of people changing trains at this remote place, was built around 1872 in place of an earlier structure.

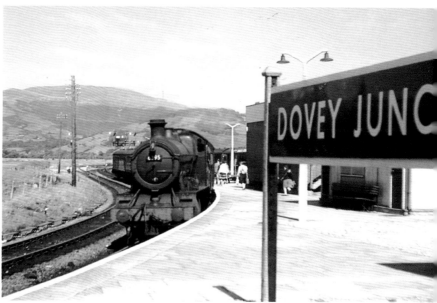

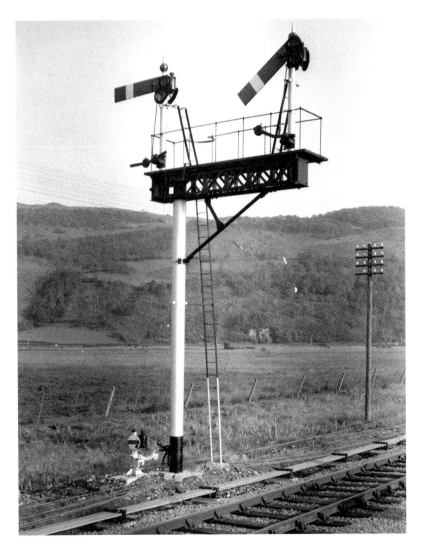

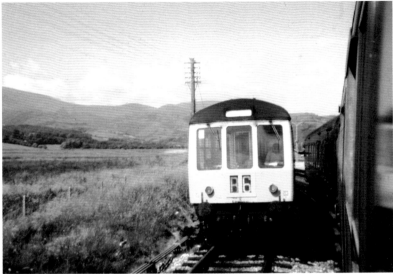

Dovey Junction

Above: A later view of Dovey Junction station, showing the Pwllheli platform on 25 July 1972; a Metro-Cammell Class 101 unit is standing alongside the platform, while a Class 108 unit waits in the adjacent loop line.

Left: Typical Great Western lower quadrant signals at Dovey Junction.

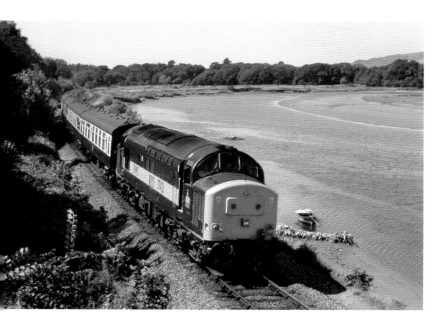

Left: Glandyfi

Passing onto the Aberystwyth line, trains leave Dovey Junction in a southerly direction, and soon reach the site of an abandoned stopping place at Glandyfi (65¾ miles), which was opened on 1 July 1863 and closed with effect from 14 June 1965. The route then follows the south shore of the Dovey, with marshes to the left and the widening estuary to the right. This part of the route is virtually dead-level, apart from a stretch of 1 in 90 and three short inclines, which are followed by three brief descents. The photograph shows Class 37 locomotive No. 37421 running alongside the Afon Dovey with the 12.10 p.m. Aberystwyth to Birmingham New Street special on 5 August 2002. This was an additional working which was arranged in connection with a Jewish conference that was being held at Aberystwyth.

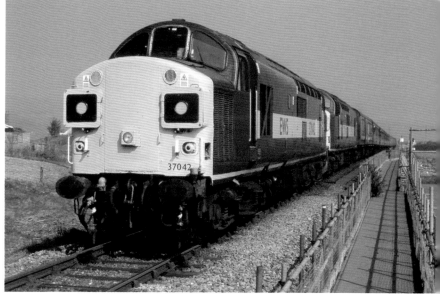

Right: Yynyslas

After following the south shore of the estuary for around 4 miles, the Aberystwyth line reaches the sea at Ynyslas (71¼ miles) – the site of a station used from 1 July 1863 until 14 June 1965, when it became yet another victim of the 1965 station closure programme. As mentioned in the historical section, if earlier plans had come into fruition Ynyslas would have been the point at which the Pwllheli line parted company with the Aberystwyth route, but, in the event, the junction was established at Dovey Junction to obviate the enormous difficulties involved in building a bridge across the mouth of the estuary. The photograph shows Class 37 locomotives Nos 37042 and 37114 *City of Worcester* crossing the Afon Leri at Ynyslas under a perfect blue sky with the 6.32 p.m. Past Time Rail Milton Keynes to Aberystwyth 'Cambrian Growler' railtour on 22 March 2003. The temporary walkway that can be seen beside the bridge was constructed of scaffolding poles which vibrated alarmingly when trains crossed the bridge at speed.

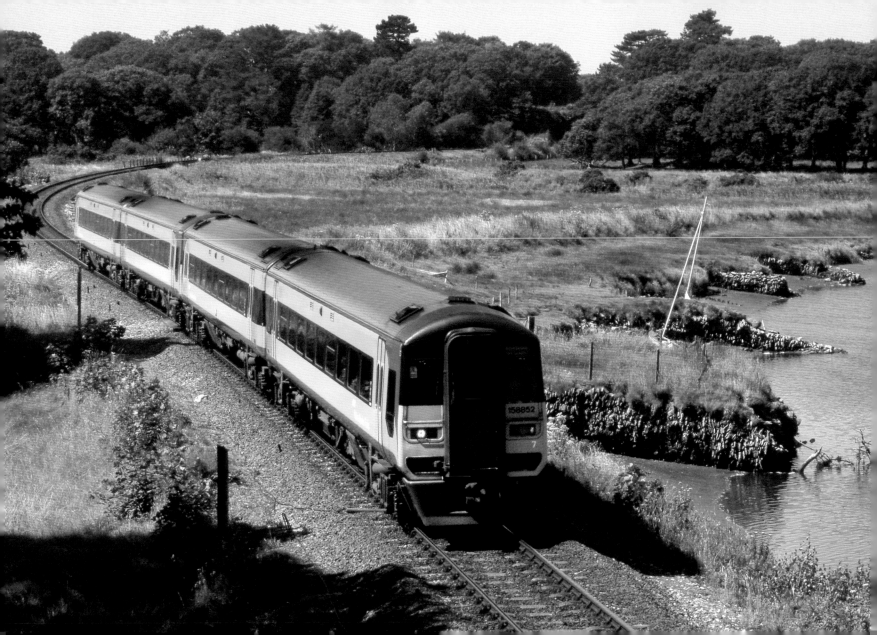

Left: Ynyslas

Central Trains liveried Class 158 unit No. 158846 heads away from the camera at Ynyslas with the 3.36 p.m. Aberystwyth to Birmingham New Street Wales & Borders service on 22 March 2003. It is not very often that one can see such a neat row of lineside daffodils! Central Trains operated the Cambrian Line from privatisation in 1997 until October 2001, when the franchise was taken over by the Wales & Borders train operating company. The line is now worked by Arriva Trains Wales.

Right: Borth

Turning leftwards, the line runs due south along a level, coastal area, with the A4353 running parallel on the seaward side. The still-extant station at Borth (73¼ miles) was opened on 1 July 1863, and it serves a small but pleasant seaside resort that has grown up along the route of the main A4353 road. The station boasts a large brick building that has, since 2011, housed a local railway museum – the old ticket office, manager's office and waiting room having been fully restored as a tourist attraction. Borth was, for many years, used as the site for a camping coach, while another of these popular holiday vehicles was stationed at nearby Glandyfi.

Opposite: Glandyfi

The 11.35 a.m. Central Trains service from Aberystwyth to Birmingham New Street runs alongside the River Dovey at Glandyfi on 5 August 2002, led by Class 158 unit No. 158852. The train will follow the Dovey all the way to Cemmes Road.

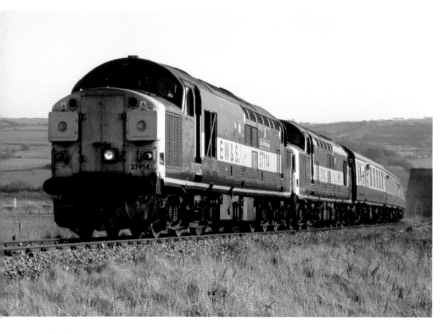

Left: **Borth**

Class 37 locomotive No. 37114 *City of Worcester* and un-named sister locomotive No. 37042 pass Borth with the 4.20 p.m. Past Time Rail Aberystwyth to Milton Keynes 'Cambrian Growler' railtour on 22 March 2003.

Right: **Bow Street**

On leaving Borth, the line curves onto a south-easterly alignment and, heading away from the sea, trains are faced with a 1 in 75 climb towards the closed station at Llandre (75¾ miles), followed by a corresponding descent to the site of Bow Street station (77¾ miles). These two stopping places were opened on 23 June 1863 and closed with effect from 14 June 1965. Bow Street, shown in this Edwardian postcard scene, sported a goods yard and a crossing loop. Bow Street is followed by another unexpected 'hump' in the gradient profile, with short stretches of 1 in 75 gradients on either side of the miniature 'summit'. The route then turns onto a north-westerly heading for the final approach to Aberystwyth, and, with the narrow gauge Vale of Rheidol Railway running alongside, trains approach their destination.

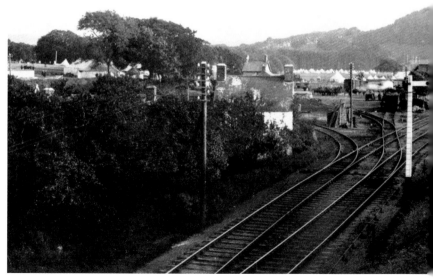

Aberystwyth – Evolution of the Station

When opened on 24 June 1864, Aberystwyth (81½ miles) had been little more than a branch line terminus, and its modest station facilities soon became totally inadequate – the deficiencies of the original layout became even more apparent after 12 August 1867, when the 'Manchester & Milford Railway' completed its line from Strata Florida to Aberystwyth. In an attempt to alleviate this problem, the arrival platform was lengthened and the passenger accommodation was considerably improved, while in 1872 canopies were erected over both the arrival and the departure platforms.

The station was extensively rebuilt after the 1922 grouping, and as a result it became a typical Great Western terminus with five long platforms. The platforms were numbered in sequence from 1 to 5, Platform 1 being on the north side of the terminus, while platforms 2 and 3 were in the centre and platforms 4 and 5 were on the south side of the station. Engine-release roads were strategically situated between platforms 2 and 3, and 4 and 5, while the main station building was an L-shape structure with its longitudinal axis parallel to the platforms. The platforms were covered by extensive canopies with typical GWR 'V-and-hole' fretwork, and there was a spacious goods yard on the north side of the passenger station. The goods yard contained a range of accommodation, including coal wharves, cattle-loading pens, a 6-ton yard crane and a large red-brick goods shed. Aberystwyth motive power depot was situated to the east of the passenger station. The shed building was a two-road, brick structure dating from the 1930s, while the depot contained the usual offices, a coaling plant and a locomotive turntable.

The upper picture shows the street façade of the rebuilt station, completed in 1925. The GWR was, at that time, promoting Aberystwyth as 'the Biarritz of Wales', and this advertising campaign was reflected in the architecture of the new two-storey terminal building, which incorporated Tuscan pilasters, a continuous cornice and a square clock tower with an octagonal roof. The interior accommodation incorporated a large tearoom with a sprung floor, which could be used for dances and similar functions during the summer season. The lower view is looking eastwards along the platforms.

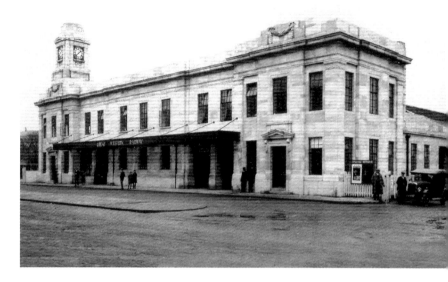

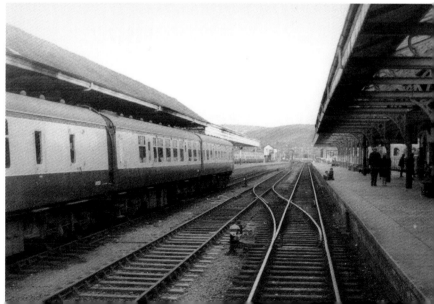

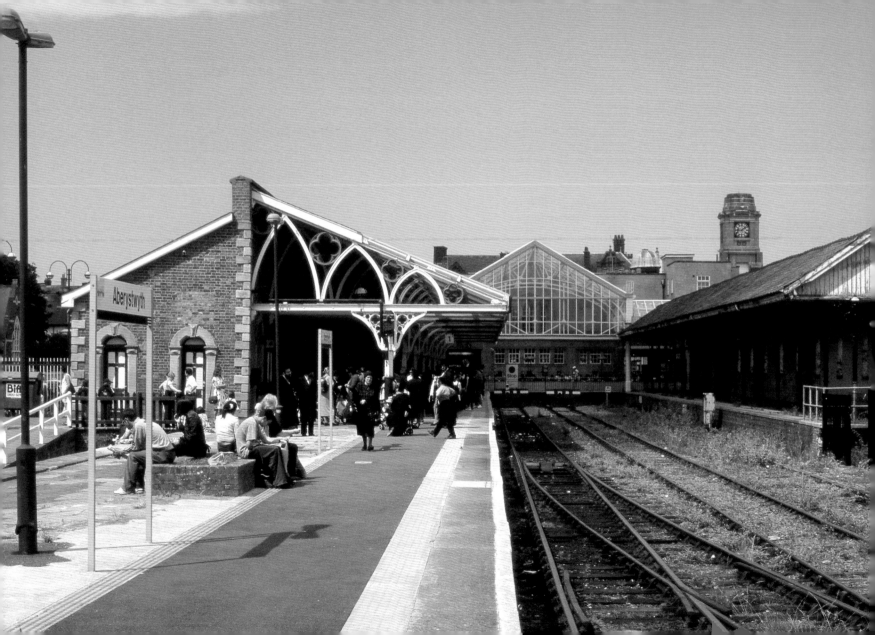

Aberystwyth – The Vale of Rheidol Line

Above: For railway enthusiasts, the most interesting feature at Aberystwyth station is perhaps the narrow gauge Vale of Rheidol Railway, which provided a useful link between Aberystwyth Harbour and various mines in the Rheidol Valley; the railway also served as a popular tourist amenity, carrying large numbers of day trippers and excursionists to its upper terminus at Devils Bridge. The Vale of Rheidol Railway was incorporated by Act of Parliament on 6 August 1897, and the line was opened for regular passenger traffic on 22 December 1902. This 1 foot 11½ inch gauge route was absorbed by the Cambrian Railways in 1913, and it passed into Great Western control at the grouping, becoming part of the British Railways system in 1948. The upper picture shows Vale of Rheidol 2-6-2T No. 1213 at Aberystwyth, probably during the 1930s. This engine was built by Messrs Davies & Metcalfe of Romiley in 1902, and rebuilt by the GWR at Swindon during the 1920s; in BR days it became VoR No. 9 *Prince of Wales*.

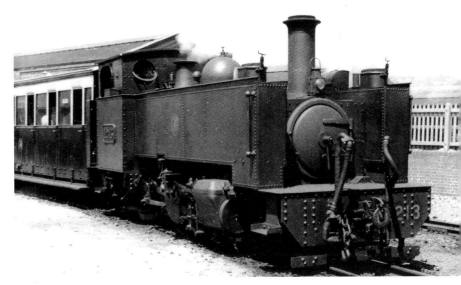

Below: When opened in 1902, the Vale of Rheidol line had terminated in a small station near the Afon Rheidol. In 1925, the GWR extended the line across Park Avenue to a new and more convenient terminus beside the standard gauge station. A further change took place in May 1968, when the narrow gauge line was diverted into platforms 4 and 5 – the former Manchester & Milford bays on the south side of the main line station. The Manchester & Milford line had been listed for closure in the notorious Beeching Report, and after the usual public inquiry, it was announced that passenger services between Carmarthen and Aberystwyth would be withdrawn with effect from 22 February 1965; as this was a Monday, the last trains ran on Saturday 20 February 1965.

Opposite: Aberystwyth

A general view of Aberystwyth station looking west towards the terminal buffer stops on a gloriously sunny 5 August 2002. This trainless scene gives an uninterrupted view of the station buildings and ornate platform awnings. The former Platform 3 is the only platform still in use for standard gauge services, and it has now been designated Platform 1.

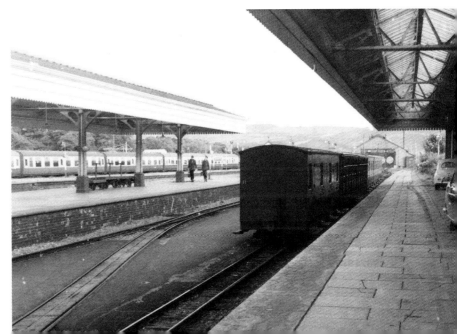

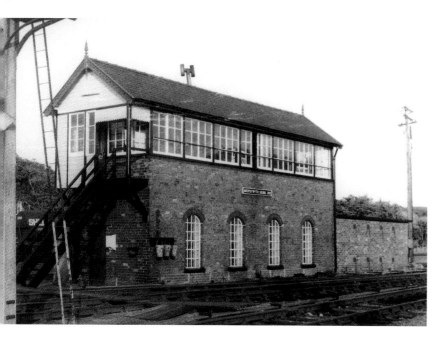

Right: Aberystwyth

Vale of Rheidol 2-6-2T No. 7 *Owain Glyndwr* passes Aberystwyth Signal Box with a train from Devil's Bridge on 25 July 1972. In 1968, the three Vale of Rheidol locomotives appeared in BR corporate blue livery, with 'double arrow' logos on their tank sides. Purists objected to this change of livery, although some enthusiasts argued that the new colour scheme suited the three narrow gauge locomotives. The Vale of Rheidol Railway was, by that time, BR's last steam-worked line – a situation that persisted until 1989 when the railway was privatised, its new owners being the Brecon Mountain Railway. A further change of ownership took place in 1996 when the VoR was sold to the Phyllis Rampton Narrow Gauge Railway Trust.

Left: Aberystwyth – The Signal Box

The terminus was signalled from a large signal cabin that was sited to the east of the platforms. This brick-and-timber structure was of typical Cambrian Railways design, with a gable roof and a characteristic semi-open porch at the west end. It was erected by Dutton & Co. in 1893, and was originally equipped with a seventy-one-lever frame, although this was soon extended to seventy-eight levers in order to deal with increasing volumes of traffic, while in 1924 the Great Western installed an even larger 100-lever frame. The box remained in use until April 1982, after which the lines in the area were controlled from Machynlleth as part of the RETB signalling system.

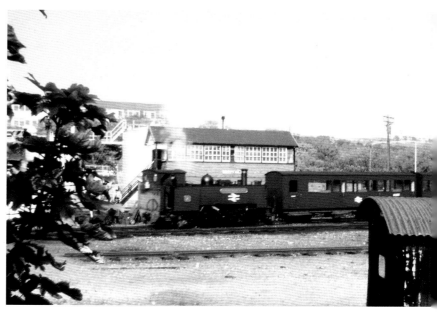

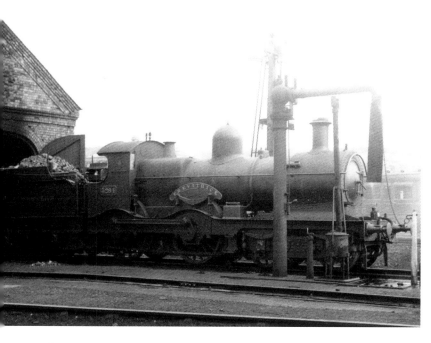

Right: Aberystwyth – A Selection of Tickets

Some Edmondson card tickets issued at Aberystwyth and other stations on the western section of the Cambrian main line, including a Cambrian Railways third class single from Machynlleth to Glandyfi. Aberystwyth issued 175,936 tickets in 1923, the corresponding figures for 1929 and 1932 being 108,280 and 74,068 respectively. The decline in the number of ordinary ticket sales can be explained by the increasing use of season tickets – over 1,000 season tickets being sold per year during the mid to late 1930s. In 1935, Aberystwyth issued 66,296 ordinary tickets and 1,499 season tickets, while in 1938 this Welsh seaside station issued 53,327 tickets and 1,332 seasons. Goods traffic amounted to around 50,000 tons per annum throughout the 1920s and 1930s. In more recent years, the station has generated around 300,000 passenger journeys per annum.

Left: Aberystwyth – A Duke on Shed

Aberystwyth engine shed was sited to the west of the platforms in the 'V' of the junction between the Cambrian main line and the Manchester & Milford route. The photograph, taken on 23 August 1934, shows Duke Class 4-4-0 No. 3264 *Trevithick* standing outside the original shed on 23 August 1934. The two-road shed building was replaced in 1938, the new shed being a steel-framed brick-clad structure measuring approximately 150 feet by 35 feet at ground level. In January 1948, Aberystwyth's allocation included Manor Class 4-6-0s No. 7802 *Bradley Manor* and 7803 *Barcote Manor*, together with six 'Dukedog' 4-4-0s, five 2251 Class 0-6-0s and three tank locomotives. In 1968, the trackwork within the shed was narrowed in order that the building could accommodate the three Vale of Rheidol locomotives.

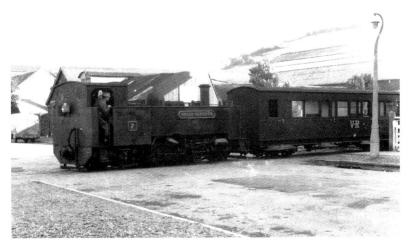

Aberystwyth – The Vale of Rheidol Railway

Left: Vale of Rheidol Railway 2-6-2T locomotive No. 7 *Owain Glyndwr* crosses Park Avenue. This crossing was abandoned in 1968 when the narrow gauge line was re-routed into the main line station. Locomotive No. 7 was one of two new engines built at Swindon by the GWR in 1923 for service on the VoR line, the other being No. 8 *Llewelyn*. The engines received their names in 1956.

Below left: Vale of Rheidol 2-6-2T No. 9 *Prince of Wales* takes water at Aberffrwg, the principal intermediate station on the Vale of Rheidol route.

Below right: A rear view of 2-6-2T No. 8 *Llewelyn* at Devil's Bridge on 23 July 1972. The Vale of Rheidol locomotives run chimney first towards Devil's Bridge, and bunker first on the downhill journey to Aberystwyth.

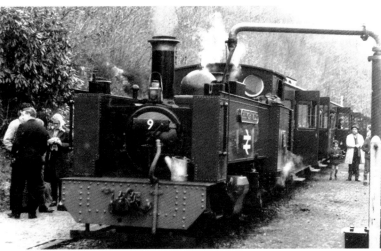

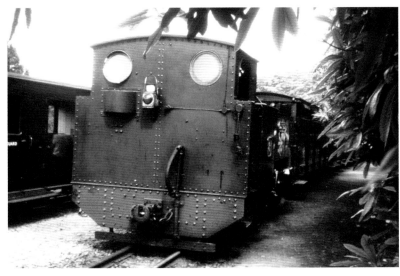

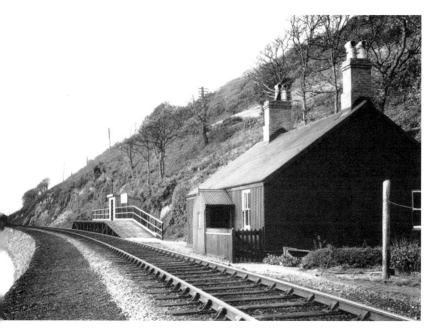

Left: Abertafol Halt

Returning to Dovey Junction, we can now resume our journey to Pwllheli along the Cambrian Coast line. Having crossed the Afon Dovey on a trestle bridge, the railway traverses an area of marshland before reaching Gogarth Halt (66½ miles from Shrewsbury). This timber-built halt was opened by the GWR on 9 July 1923 and closed in May 1984 because of the deteriorating structural condition of its wooden platform. Abertafol Halt (68¼ miles), just 2 miles further on, was opened on 18 March 1935 but, like Gogarth, its structural condition eventually became so precarious that services were suspended in May 1984, pending completion of the statutory closure procedure. The photograph shows Abertafol Halt shortly after opening; the railway cottage, which predated the halt, provided accommodation for one of the local permanent way men.

Right: Abertafol

Hugging the wooded north shore of the estuary, the winding single line runs along the seawall, affording glimpses of the Aberystwyth line on the opposite bank. The line is virtually dead level, although there are two short tunnels, both around 200 yards in length, on the east side of Abertafol Halt at Frongoch and at Morfa Bach, and two more on either side of Penhelig – all of these tunnels have very tight clearances. The photograph, from a 35 mm colour slide taken on 25 July 1972, shows the view from the windows of a Metro Cammell Class 101 diesel multiple unit near Abertafol Halt; the Dovey estuary is over a mile wide at this point.

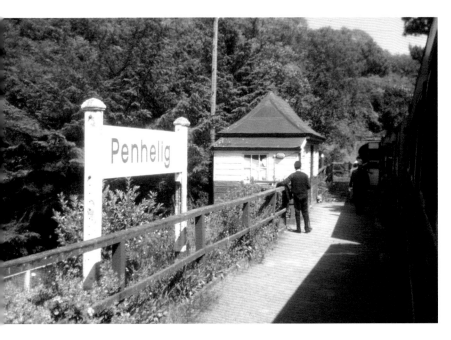

Right: **Penhelig**
Class 37 locomotive No. 37411 *Caerphilly Castle* skirts the Dovey Estuary at Penhelig with the 6.41 a.m. Pathfinder Tours Sheffield to Pwllheli 'Snowdonian' railtour on 20 May 2006. The rain had just stopped, although this slight improvement in the weather had done little to dispel the gloom of a typically dreary Welsh day – note the heavy storm clouds looming over the mountains in the background.

Left: **Penhelig**
Opened by the GWR on 8 May 1933, Penhelig Halt (70 miles) is situated in a picturesque setting on a curved section of line between two closely spaced tunnels – Penhelig Tunnel, to the east of the halt, being 191 yards in length, whereas Craig-y-Don Tunnel, to the west, is somewhat longer, with a length of 533 yards. The infrastructure here consists of a single platform on the up side of the line, with a wooden 'pagoda' style building. Internally, this diminutive structure formerly contained a waiting room and a small ticket office, but the latter facility is no longer available. The photograph was taken on 25 July 1972 – at which time Penhelig was still a staffed station.

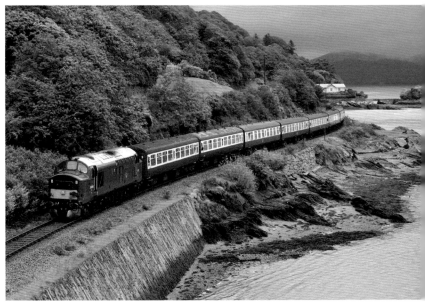

Aberdovey

Serving a pleasant seaside resort, Aberdovey station (71 miles) is barely a mile beyond Penhelig. When opened between Aberdovey and Llwyngwril on 24 October 1863, the Aberystwyth & Welsh Coast Railway had terminated in a temporary station at Aberdovey Harbour, where a pier and other facilities had been built by the contractor, Thomas Savin, in order that construction materials could be ferried across the Dovey from Ynylas. The harbour station was used for passenger traffic until 14 August 1867, when the main line to Dovey Junction was brought into use; thereafter, the harbour sidings remained in operation as a goods yard until final closure in May 1964.

The new station incorporated Up and Down platforms and a crossing loop, the main station building, dating from around 1872, being on the Up side, while the harbour branch diverged from the main line at the east end of the Down platform. The station building sported a full-length platform canopy that is said to have been moved to Aberdovey from Pwllheli in 1912. There were no goods facilities, as such, apart from loading docks for livestock, horse boxes and vehicles – most of Aberdovey's goods traffic being handled in the harbour sidings. The upper picture is looking east towards Welshpool during the early years of the twentieth century, the end-loading dock for horseboxes and carriages is visible beyond the end of the up platform. The lower photograph is looking north towards Pwllheli c. 1962. The signal box that can be seen on the Down platform contained a twenty-lever frame.

Aberdovey's crossing loop was taken out of use in 1968 and the station became an unstaffed halt in 1971. All trains now use the remaining platform on the Up side, while the former station building, now in private use, has lost its canopy.

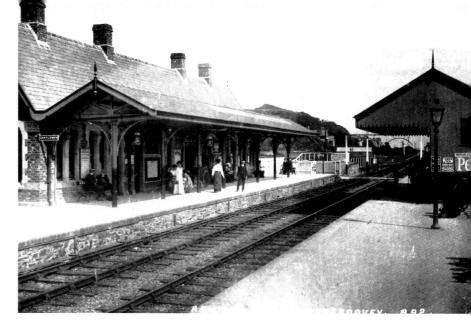

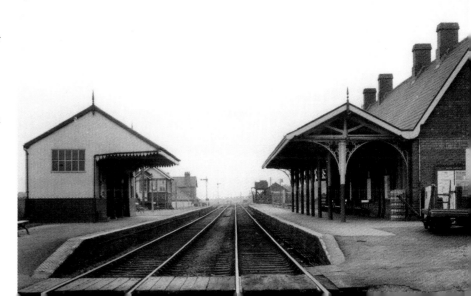

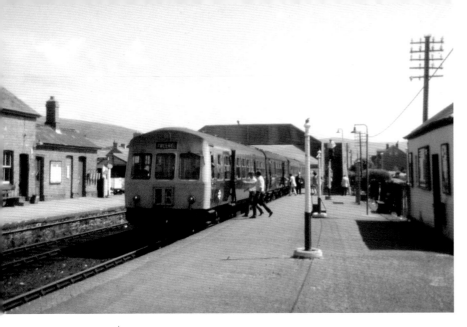

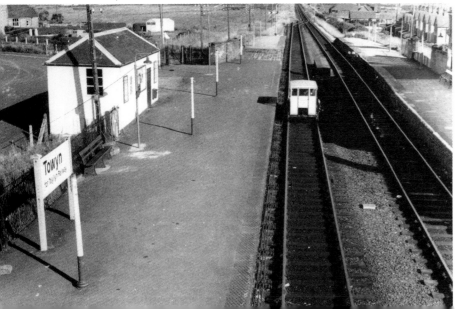

Tywyn (formerly Towyn)

Having left Aberdovey in a westerly direction, down trains are soon heading due north as the line swings through a full 90 degree turn. After around 2 miles, the railway turns onto a north-westerly heading as it approaches Tywyn (79¼ miles) – one of the more important stopping places en route to Pwllheli, and the 'junction' for the narrow gauge Talyllyn Railway. When opened on 24 October 1863, Tywyn had evidently been provided with very basic facilities but, after a few years, the Cambrian began work on a permanent station. On 2 June 1870, a correspondent wrote to the *Cambrian News & Merionethshire Standard* to say that the new station was rapidly approaching completion, and would be 'ready for public use in the course of the week'.

The new station building, on the Up platform, was a brick-built structure with a full-length canopy and a steeply pitched hipped roof. Internally, it contained a refreshment room as well as the usual booking office and waiting room facilities. The refreshment room became a matter of extreme controversy when the building was under construction, as the local Non-conformists objected to the sale of alcohol at the station and prepared a petition with the aim of preventing the granting of a licence. This in itself caused considerable offence, and the *Cambrian News & Merionethshire Standard* correspondent suggested, somewhat sarcastically, that this was no way for the townspeople to show their 'appreciation of the expense to which the Cambrian Company had gone to in providing Tywyn with the only permanent station on the Coast Section proper between Machynlleth and Pwllheli'.

The track layout at Tywyn consisted of a lengthy crossing loop and a fairly spacious goods yard – the latter facility being sited to the south of the passenger station on the Up side. One of the sidings continued southwards to reach the neighbouring Talyllyn Railway station at Tywyn Wharf, while the station was signalled from a standard GWR signal cabin on the Down side. The colour photograph shows a Class 101 unit alongside the Down platform on 25 July 1972, while the lower view is looking northwards from the footbridge around 1963. The name of the station was changed from 'Towyn' to 'Tywyn' in 1976.

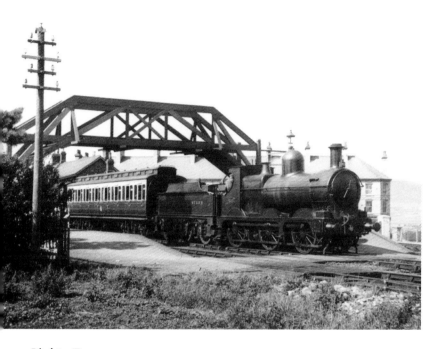

Right: **Tywyn**

A double-headed passenger working leaves Tywyn during the 1930s, the leading engine being Dean Goods 0-6-0 No. 2465. The goods yard, which can be seen behind the locomotives, contained a goods shed, coal wharves and a cattle-loading dock, while an additional siding to the north of the station was used for gas works traffic. The siding in the foreground was the down refuge siding. Much of this Victorian infrastructure has been removed, and Tywyn is now an unstaffed halt, although the station has retained its crossing loop. The main station building is no longer in railway use, having been adapted for other uses, including offices, a charity shop and, more recently, the Tywyn Spiritualist Church, which arranges the times of its services to coincide with the railway timetable. The canopy was dismantled during the 1960s and moved to Abergynolwyn, on the Talyllyn Railway.

Left: **Tywyn**

Dean Goods 0-6-0 No. 2345 waits at Tywyn with an Up passenger train on 23 August 1934; the wooden footbridge was erected in 1899. Tywyn booked approximately 37,000 tickets each year during the early 1920s, falling slightly to around 30,000 ordinary bookings per annum during the early to mid-1930s – the apparent decrease being attributable largely to the increased use of season tickets by regular travellers. In 1923, for example, the station issued 37,889 tickets and 9 seasons, whereas in 1933 ticket sales amounted to 30,938 ordinary tickets and 73 seasons.

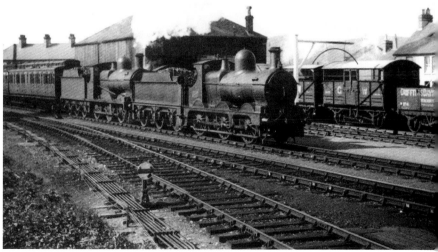

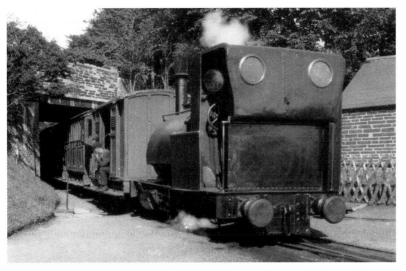

Tywyn – The Talyllyn Railway

Left: Talyllyn Railway 0-4-2ST No. 1 *Talyllyn* enters Tywyn Wharf station with a passenger train, probably around 1935. Built to a gauge of 2 feet 3 inches, the Talyllyn Railway was authorised on 5 July 1865 and opened in October 1866. The original passenger station was at Towyn Pendre, but passenger services were subsequently extended southwards to Tywyn Wharf.

Below left: Having been closed at the end of the 1950 season, the railway was reopened by a group of railway enthusiasts in the following year, the first 'preservation era' trains being run on Whit Monday, 14 May 1951. The Talyllyn Railway thereby became Britain's very first preserved line. Indeed, the railway claims to be first 'The World's First Preserved Railway'. The photograph shows TR No. 4 *Edward Thomas*, one of the former Corris Railway locomotives, at Tywyn Wharf on 25 July 1972.

Below right: TR No. 1 *Talyllyn* at Abergynolwyn on 3 June 2012. The Talyllyn Railway is now a major tourist attraction, carrying around 50,000 passengers per annum.

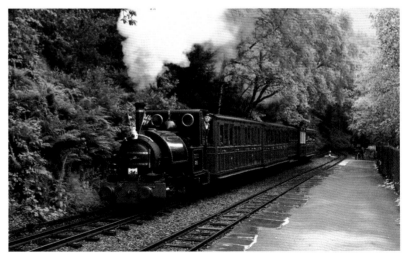

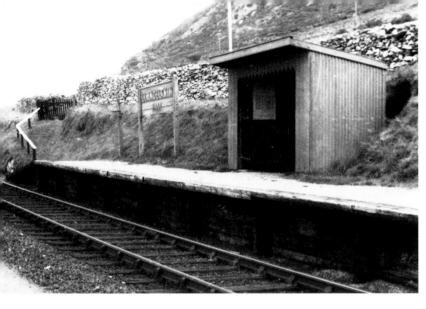

Left: **Tonfanau and Llangelynin Halt**
Travelling north, the line crosses the Afon Dysynni on a girder bridge and then continues to Tonfanau, where a station was established in 1896. This wayside stopping place consisted of a group of undistinguished buildings on a single platform, with a level crossing immediately to the south. The station served a nearby army camp that was built during the Second World War and remained in use during the Cold War era; in 1972 the camp provided temporary accommodation for over 3,000 Ugandan Asians who had been expelled from their homes by the African dictator Idi Amin. Tonfanau camp has been closed for many years, but the station remains in operation, with a resurfaced platform and a simple bus stop style waiting shelter.

Climbing gradients as steep as 1 in 75, trains reach Llangelynin Halt (79¼ miles), which was opened by the GWR on 7 July 1931 and closed following a dispute with the Health & Safety Executive over the provision of electric lighting. BR decided that the expenditure that would have been incurred could not be justified at this remote and little used stopping place and promptly closed the halt with effect from Saturday 26 October 1991, the last trains having called on Friday 25 October.

Right: **Llangelynin Halt**
Class 37 locomotive No. 37411 *Caerphilly Castle* is pictured passing the site of Llangelynin Halt with the 4.22 p.m. Pwllheli to Sheffield returning 'Snowdonian' railtour on 20 May 2009. This dramatic location is on the coast between Tywyn and Barmouth near the notoriously unstable cliffs at Friog, where the western extremity of the Cader Idris range meets the Irish Sea. Having descended towards the extant station at Llwyngwril (81 miles), the line has to climb steeply at 1 in 66 around precipitous cliffs – this being the place in which 2-4-0 No. 29 *Pegasus* was derailed by a rock fall on 1 January 1883 (see page 105). A second derailment took place on 4 March 1933 when former Cambrian 0-6-0 No. 54 (GWR No. 848) struck a landslide and plunged over the cliffs onto the rocks below. Both enginemen were killed. As a result of this second disaster, a Swiss-style avalanche shelter was belatedly constructed in order to consolidate the cliffs and deflect falling debris.

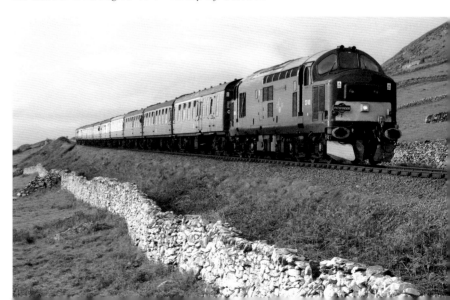

RAILWAY INFORMATION

SOUTH AND CENTRAL WALES

South and Central Wales with its magnificent mountain scenery, its Castles, and many seaside resorts, is served by frequent Express trains from PADDINGTON, also through trains from the Midlands and the North.

Camping Coaches, fully equipped with bed clothes, linen, cutlery, crockery, cooking utensils, etc., are available at the following stations in South and Central Wales:

Caernarvonshire	Cardiganshire		Glamorganshire
Abererch	Aberayron (2)	Llanilar	Lavernock (2)
	Borth	Llanrhystyd Road	Sully
	Glandyfi		
Carmarthenshire			
Ferryside			
	Merioneth		Pembrokeshire
Aberdovey (3)	Arthog	Barmouth Junction	Manorbier
Carrog	Dolgelley	Dyffryn Ardudwy	Penally
Fairbourne	Llwyngril	Talsarnau	Saundersfoot

See pages xvii to xxxvii for further information.

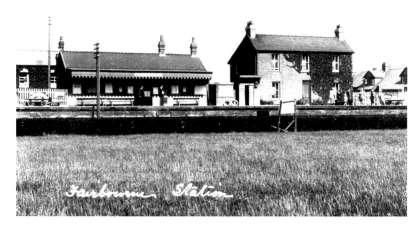

Fairbourne Station

Fairbourne

Above: Coasting downhill on a 1 in 55 falling gradient, trains reach the station at Fairbourne (83¾ miles), which was not one of the original stopping places, having been opened on 1 July 1897. Its modest facilities consisted of a single platform on the Down side, with a level crossing at the south end, and a sidings for goods traffic. The station building, now a private dwelling, was a single-storey structure with a full-length canopy, as shown in this Edwardian postcard view.

Left: The Cambrian Coast route was associated with camping coaches for many years. Such coaches were first introduced by the London & North Eastern Railway during the mid-1930s, but the Great Western was quick to follow suit, and in 1934 *The Railway Magazine* announced that redundant GWR passenger vehicles were being adapted for use as 'railway caravans for the holiday camper'. Camping coaches continued to be used during the British Railways era, one of these vehicles being stationed at Fairbourne, as shown in this 1958 advertisement. Other camping coaches were available at Borth, Glandyfi, Aberdovey, Barmouth Junction, Dyffryn Ardudwy, Llwyngril and Talsarnau.

Fairbourne – The Fairbourne Railway

The Fairbourne Railway was originally built by Arthur McDougall, of self-raising flour fame, as a 2-foot gauge horse-worked tramway for the carriage of building materials and, later, passengers. It was opened in 1890 from Fairbourne station to a terminus at Penrhyn Point, from where a ferry service conveyed passengers across the Mawddach Estuary to Barmouth Harbour. In 1916, the 2-mile line was purchased by Narrow Gauge Miniature Railways Ltd, a company registered in 1911 with offices at No. 112 High Holborn, London. The railway was converted to 15-inch gauge using the original rails, and a steam-worked summer passenger service was introduced for the benefit of holidaymakers in 1916. In 1922, the working of the line was taken over by the Barmouth Motor Boat & Ferry Co., while in 1825 ownership passed to the Fairbourne Estate & Development Co. Further changes of ownership took place after the Second World War, and the line is now operated as a 12¼-inch gauge line – the gauge having been altered in 1985.

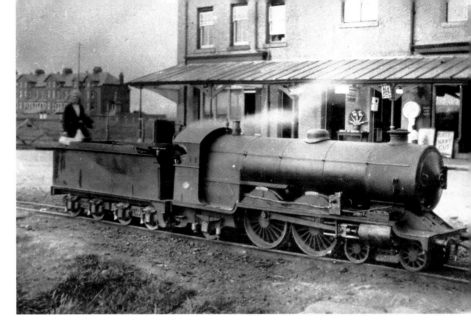

Above: Bassett-Lowke 'Little Giant' 4-4-2 No. 22 *Prince Edward of Wales* was built in 1915, and this locomotive worked on the Fairbourne line until the early 1920s, when it was sold to the Lakeside Miniature Railway at Southport. A similar locomotive, Bassett-Lowke 'Little Giant' 4-4-2 No. 32 *Count Louis*, was acquired in 1925 following the death of its owner Count Louis Zborowski. The photograph shows one of the 'Little Giants' (probably *Count Louis*) at Fairbourne around 1928.

Below: In 1916, the Fairbourne Railway obtained an 18-inch gauge Bagnall 4-2-2 locomotive (Works No. 1425) that had been built in 1893. A third rail was laid over the lower part of the line so that the engine could be employed on the line, and the engine is pictured at the northern end of the 'mixed gauge' section around 1930. The 4-4-2, which was based on Stirling's famous Great Northern Railway single-wheelers, was sold in 1936 to the Jaywick Sands Miniature Railway at Clacton.

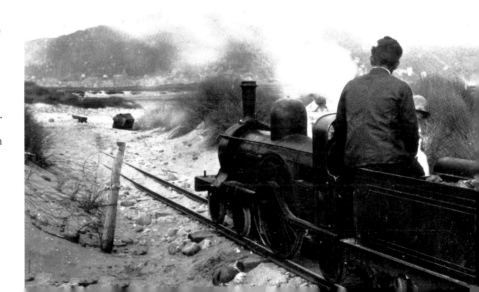

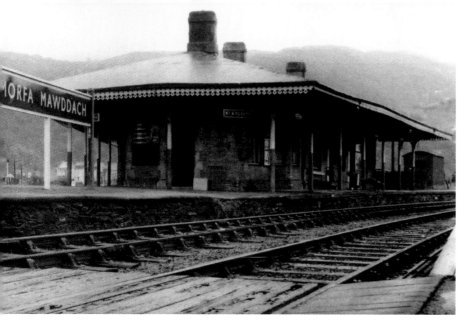

Morfa Mawddach

After running for a mile over level, marshy ground, trains reach the former junction station at Morfa Mawddach (85 miles), where the now closed line to Ruabon once joined the Pwllheli route. Trains began running to Barmouth on 3 July 1865, but the present station was not opened until 3 June 1867, when horse-drawn passenger services were inaugurated across Barmouth Bridge. The station was known as Barmouth Junction until 1960, when the name was changed to Morfa Mawddach.

Morfa Mawddach had a triangular layout, with its platforms at the northern end of a triangle; a north-to-east curve enabled through running to take place between Pwllheli and Ruabon, but the south-to-east curve was not signalled for through running. The upper picture shows the main station building from the north, the Up and Down main line platforms being visible in the foreground; this hip-roofed structure was erected around 1872 as part of a programme of new station construction that was being implemented on the Cambrian system at that time. The lower photograph is looking northwards along the Up and Down Ruabon platforms, the Up platform being on the right, while the thirty-eight-lever Great Western signal box, dating from 1931, can be seen in the distance. A bay platform was provided at the south end of the down platform, and this was used as the parking place for one of the ever-popular camping coaches.

Passenger services between Ruabon and Barmouth were listed for closure in the Beeching Report, but closure was postponed because of delays in arranging a replacement bus service. In the event, severe flooding on 12 December 1964 decided the issue by damaging the line to such an extent that services were suspended. Rail services resumed between Barmouth and Dolgellau on 14 December 1964, and other parts of the line were reopened on 17 December. In the interim, however, it had been decided that final closure would take effect from 18 January 1965, and the last trains accordingly ran on Saturday 16 January. Morfa Mawddach station remained in operation, but the station is merely a shadow of its former self, with just one platform and a simple bus stop waiting shelter.

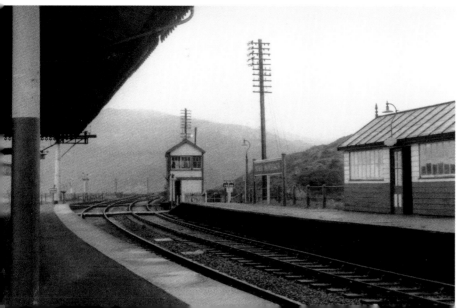

Стоп.

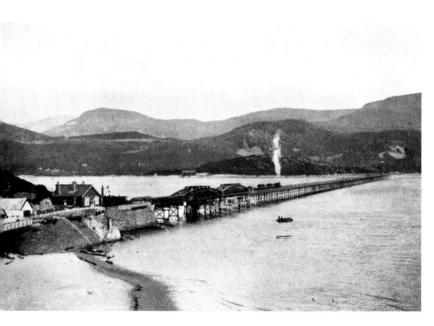

Left: Barmouth
Having departed from Morfa Mawddach, trains cross Barmouth Bridge – this trestle viaduct being perhaps the most famous feature of the Cambrian Coast line. The bridge consists of no less than 113 spans, each approximately 18 feet, together with four larger spans, including a swinging span measuring 136 feet overall – the latter being mounted on a central pivot. The bridge was rebuilt in 1899, and again in 1904, but in April 1980 an inspection revealed that many of the wooden piles had become infested with *Teredo Navalis* (shipworm), and goods traffic was immediately suspended. The bridge was closed to all traffic in the following October, although train services were maintained between Machynlleth and Morfa Mawddach and between Barmouth and Pwllheli – the latter services being worked worked by half-a-dozen multiple unit sets that had been marooned on the north side of the Mawddach. Thankfully, the stricken bridge was reopened in May 1981 after BR had carried out extensive repairs and applied protective glass-reinforced casings to 498 timber piles.

Right: Barmouth
Gaining the north side of the estuary, trains run through the seaside town of Barmouth, the station (86½ miles), being preceded by a 70-yard tunnel. Barmouth retains its station buildings and crossing loop, the main station building being on the Up side, while a level crossing is sited immediately to the south. The present station building was erected in 1873 and, in its report on the new facilities, the *Cambrian News & Merionethshire Standard* described the station as 'a handsome and commodious building and an ornament to the town'. The building was designed by George Owen, the Cambrian Railways Engineer. Prior to rationalisation, there had also been Up and Down bay platforms, but, as a result of space restrictions, the lengthy Up bay was sited to the south of the level crossing – giving it the appearance of a separate 'excursion' platform. The photograph shows a GWR 517 Class 0-4-2T in the aforementioned bay platform with a Dolgellau branch train during the 1930s, the main station building being visible in the background.

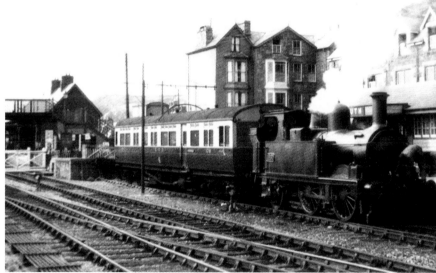

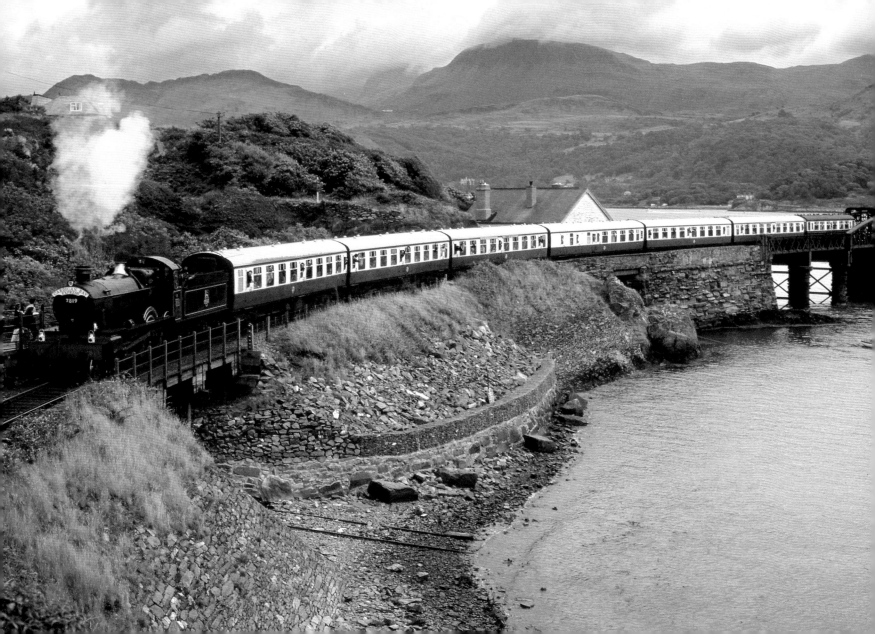

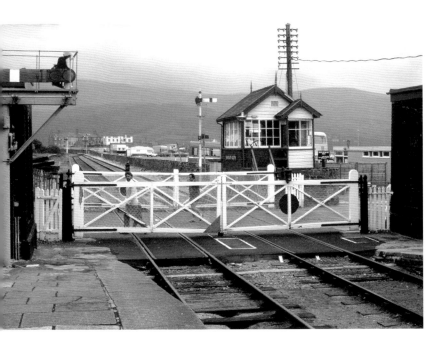

Opposite: Barmouth

Steam operation returned to the Cambrian line for one season in the summer of 1987, using locomotives hired from the Severn Valley Railway such as Manor Class 4-6-0 No. 7819 *Hinton Manor*, Ivatt Class 2MT 2-6-0 No. 46443 and BR Standard Class 4MT 4-6-0 No. 75069. The photograph shows *Hinton Manor* crossing Barmouth Bridge at the head of the 11.20 a.m. 'Cardigan Bay Express' railtour from Machynlleth to Barmouth on 2 August 1987. The rails that can be seen beneath the bridge are the rusty remnants of an old slipway. The 1987 steam workings were highly popular, but BR claimed that the exercise was not financially successful and would not be repeated. However, steam-hauled excursions returned to the Cambrian route in 1991 as part of the 'Machynlleth 700' events held to celebrate the granting of the town's charter.

Barmouth

Above: A plethora of vintage Great Western infrastructure at Barmouth, pictured on a very overcast 18 June 1982. The lower quadrant semaphore signals, level crossing gates and Cambrian Railways signal box have all now been swept away although, the signal box, which was closed in 1988, has fortunately found a new home on the Llangollen Railway.

Below: This early 1960s view is looking northwards along the Down platform, with the Down bay to the left of the picture and the goods shed to the right.

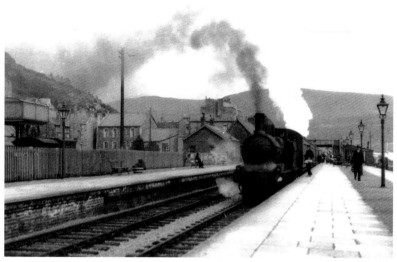

Barmouth

Left: A general view of the station, probably around 1925, with a train in the Down platform.

Below left: A glimpse of the Up bay platform during the British Railways period around 1962; this platform, which was designated Platform 4, was added by the GWR shortly after the 1922 grouping.

Below right: This view is looking southwards from the footbridge during the early 1960s. The crossover at the end of the Up bay platform enabled terminating trains to run-round. In 1923, Barmouth issued 84,751 ordinary tickets and 149 season tickets, while in 1933 ticket sales at this Welsh seaside station amounted to 51,740 ordinary tickets and 832 seasons.

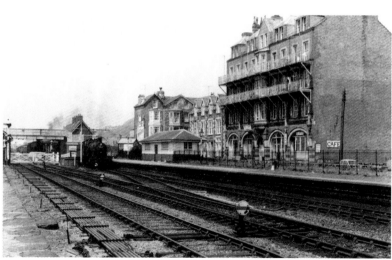

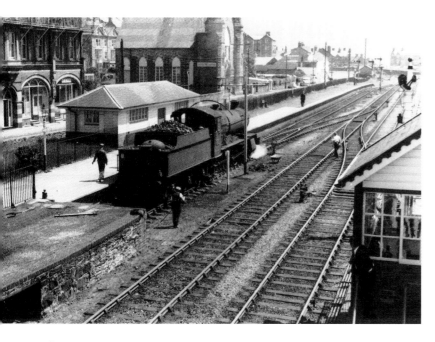

Left: **Barmouth**

A further view of Barmouth's detached up bay platform during the early 1960s, in this case looking south towards Dovey Junction; an unidentified Manor Class 4-6-0 waits in the bay, while Barmouth South Signal Box can be seen on the extreme right. Barmouth South Box contained a twenty-seven-lever frame, while Barmouth North Box, at the other end of the station, had twenty-four levers until 1924 and thirty-six thereafter. Both cabins were standard Cambrian Railways brick-and-timber structures.

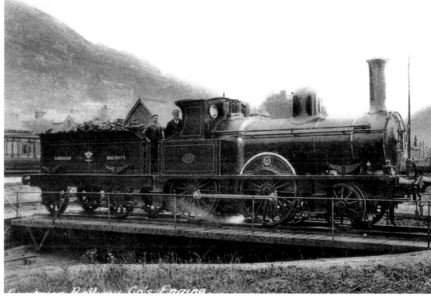

Right: **Barmouth**

Cambrian Railways 2-4-0 No. 29 poses for the camera on the small turntable at Barmouth, which was situated to the west of the down platform. One of twelve 2-4-0s built by Sharp Stewart for the Cambrian and its constituents in 1863-5, No. 29 was originally named *Pegasus*. On 1 January 1883, this locomotive was working the evening down train from Machynlleth to Barmouth when it was derailed by a landslide at the Barmouth end of the Friog Incline (see page 97), and fell 85 feet down the cliffs onto the beach below, resulting in the deaths of the driver and fireman. The engine was rebuilt after the accident, and it remained in service until 1913.

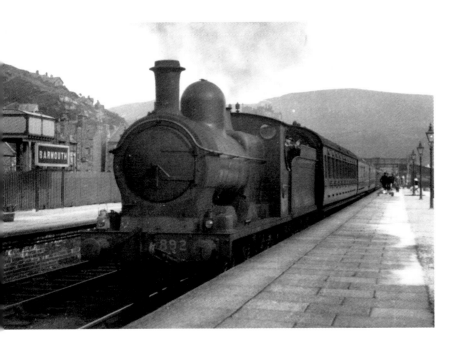

Left: **Barmouth**

Former Cambrian Railways 15 Class 0-6-0 No. 892 waits beside the down platform with a fast train to Pwllheli during the late 1930s. Fifteen of these locomotives were constructed by Beyer Peacock and Stephensons between 1903 and 1919. Some of the coaches in the lengthy train are carrying roof boards, which suggests that they are through coaches from Paddington or Birkenhead.

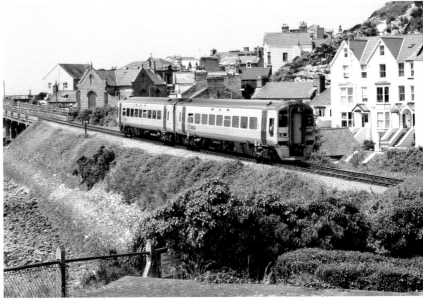

Right: **Barmouth**

Class 158 unit No. 158836 leaves Barmouth while forming the 11.32 a.m. Pwllheli to Birmingham New Street Arriva Trains Wales service on 18 June 2005; the unit is in Wales & Borders 'Alphaline' silver-grey livery. Introduced in 1989, these diesel multiple units were built in Derby by British Rail Engineering Ltd, and they now dominate services on the Cambrian line, twenty-two car-sets having been allocated to Machynlleth by 2010.

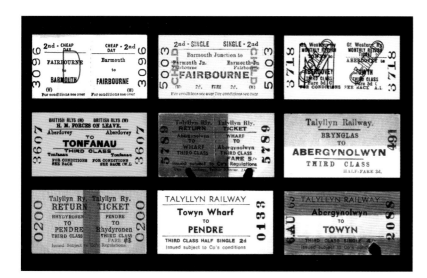

Left: **Barmouth**

An assemblage of Edmondson card tickets from the Aberdovey, Towyn and Barmouth area, including a Great Western child ticket, a British Railways forces leave ticket, and five Talyllyn tickets. Three of the colourful Talyllyn tickets were issued during the preservation era, although the other two are much older.

Right: **Talybont Halt**

Resuming their journey, trains head north-north-westwards along the coast, with the A496 road running parallel to the left. In 1914, the Cambrian opened halts at Llanaber (88 miles) and Talybont (90¼ miles), both of these being simple, single-platform stopping places; the illustration shows Talybont during the 1930s, by which time it had acquired a GWR arc-roofed waiting shelter. Talybont remains in use, but the GWR shelter has been replaced by a modern 'bus stop' waiting shelter, and the platform has been considerably extended.

Station and Llwyncadwgan, Dyffryn

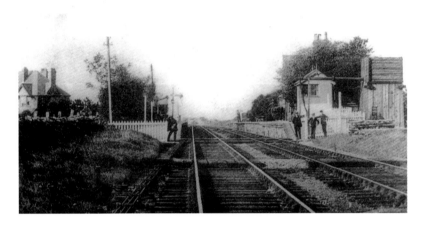

Dyffryn Ardudwy

Left: Dyffryn Ardudwy (91½ miles), the next stop, was opened on 10 October 1867. The layout here consisted of Up and Down platforms on either side of a crossing loop, as depicted in this postcard view from around 1912.

Below left: A detailed look at the main station building on the Up side, which was very similar to the buildings provided at other small stations on the Cambrian route.

Below right: This final view of Dyffryn Ardudwy is looking north towards Pwllheli during the early years of the twentieth century. In 1923, the station issued 21,400 tickets, falling to around 15,000 per annum during the early 1930s. Dyffryn Ardudwy has remained in operation, although it is no longer a passing place – the crossing loop having been removed.

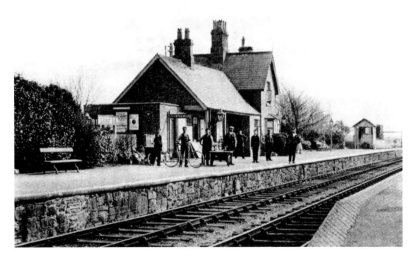

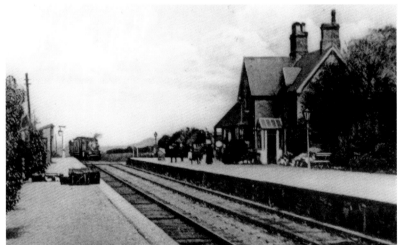

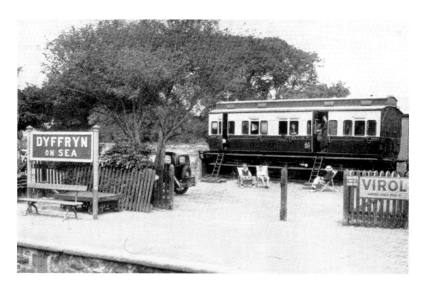

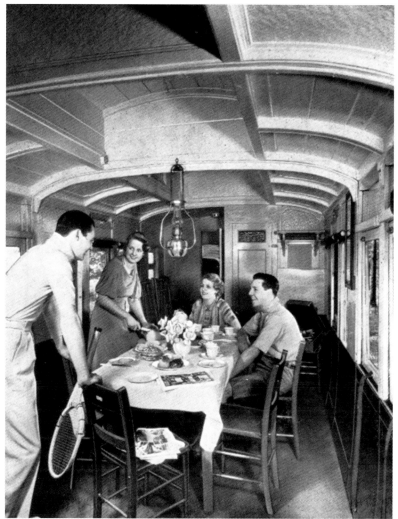

Dyffryn Ardudwy – Camping Coaches

As mentioned earlier, the Great Western introduced camping coaches in 1934, and these specially equipped holiday vehicles were so popular that the number of locations was increased to thirty-eight in the following year. The *Great Western Railway Magazine* reported that some of the 'camp coaches' were fitted out for six people, while others could accommodate parties of eight. The standard six-berth coaches contained a 'living room, kitchen and two sleeping compartments', while 'ample cupboard and wardrobe accommodation' was provided. Camping coaches were available at seven places on the Cambrian main line in the summer of 1935, the stations concerned being Afon Wen, Talsarnau, Barmouth Junction, Towyn, Borth, Bow Street and Dyffryn Ardudwy (then known as 'Dyffryn-on-Sea'). The left-hand photograph shows a camping coach parked in the goods yard at Dyffryn Ardudwy, with happy holidaymakers reclining in their deckchairs, while the right-hand view shows the 'dining room' of a GWR camping coach – note the tennis racket!

Left: Llanbedr

Llanbedr (93¾ miles), the next stopping place, is a little over 2 miles further on. Opened by the GWR on 9 July 1923, it was known for many years as 'Talwrn Bach Halt', but the word 'halt' was dropped in 1968, and in 1978 the name was changed to 'Llanbedr'. The infrastructure here consists of a segmental concrete platform on the down side of the running line, with a small waiting shelter. The photograph is looking southwards along the platform around 1963. The Great Western arc-roofed waiting shed has now been replaced by a modern bus stop style shelter.

Right: Llanbedr

A view of the halt from the adjacent fields during the early 1960s. The Cambrian Coast line was badly damaged by severe storms and tidal surges on 2/3 January 2014, some of the worst damage being sustained in the vicinity of Llanbedr, where the track was buckled by the violence of the waves, which deposited rocks and boulders on the line and washed away large quantities of ballast. Train services were suspended on the damaged section, and Network Rail immediately implemented a rolling repair programme, around 40 tons of debris being removed from the track, while over 6,000 pieces of 'rock armour' were reinstated to protect the line from the sea. At the same time, more than 1,000 sleepers were replaced, together with 2,500 tons of ballast. The line was reopened between Barmouth and Harlech on 1 May 2014, the resumption of services being two weeks ahead of schedule.

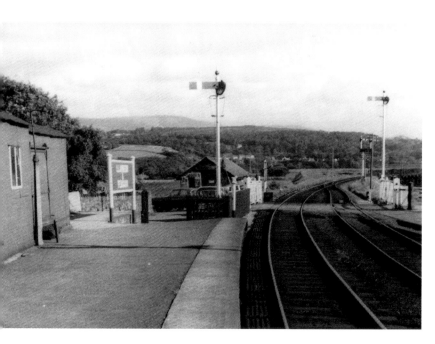

Left: Llanbedr & Pensarn

Llanbedr & Pensarn station (94½ miles) is less than a mile from Llanbedr. It was opened as 'Llanbedr' on 10 October 1867, the name 'Llanbedr & Pensarn' being adopted during the 1880s, though in 1978 there was a further change in terms of nomenclature when it became 'Pensarn'. In the days of steam, the layout here had consisted of a crossing loop, with a single platform on the Up side – the loop being signalled for bi-directional working. The station is situated beside a tidal creek which is crossed by a short wooden viaduct, while the now closed goods yard was sited next to a small wharf. The photograph is looking southwards from the curved platform, the timber trestle bridge being visible in the right background; the level crossing gave access to the goods yard and the aforementioned wharf. Goods facilities were withdrawn in 1964, and the signal box was closed in 1969, when the crossing loop was abolished. The station buildings have now been replaced by a bus stop style shelter.

Right: Llandanwg Halt

Situated just half a mile beyond Pensarn, Llandanwg Halt (95 miles) was opened by the GWR on 8 November 1929. The platform, on the down side, has a length of just 75 feet – in other words it is barely half the length of the two-car class '158' units employed on the Cambrian route. Access from the adjacent road overbridge is by means of a sloping pathway, while the halt has retained its traditional waiting shelter, which has been attractively painted in a mid-blue livery.

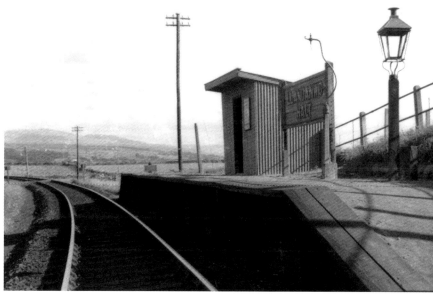

Harlech

Continuing north-north-eastwards along the shoreline, trains soon reach Harlech (97 miles), a more important station that was opened on 10 October 1867. The station has retained its crossing loop, while the whitewashed station building on the Down side has survived as a private dwelling. The platforms are linked by a lattice girder footbridge, and large, open-fronted waiting shelters are provided on both sides. The goods yard, which was on the Up side and had contained a loop siding, was closed in 1964, while the twenty-nine-lever signal box was abolished in 1988.

The upper picture, looking northwards from the footbridge, shows Class 158 unit No. 158830 arriving at Harlech station with the 1.38 p.m. Pwllheli to Birmingham International service on 20 October 2014. Note the grass covered platforms; only the sections near the station building are now in use, with the rest having been fenced off. The lower view, also taken on 20 October 2014, is looking southwards from the footbridge, with the main station building visible to the right.

Opposite: Harlech

A busy moment at Harlech on 20 October 2014, as local schoolchildren prepare to board a couple of trains that are crossing in the station. In the foreground Class 158 unit No. 158821 has just arrived with the 10.09 a.m. Arriva Trains Wales service from Birmingham International to Pwllheli, while sister unit No. 158830 waits in the up platform with the 1.38 p.m. Pwllheli to Birmingham International service. Harlech Castle features prominently in the background.

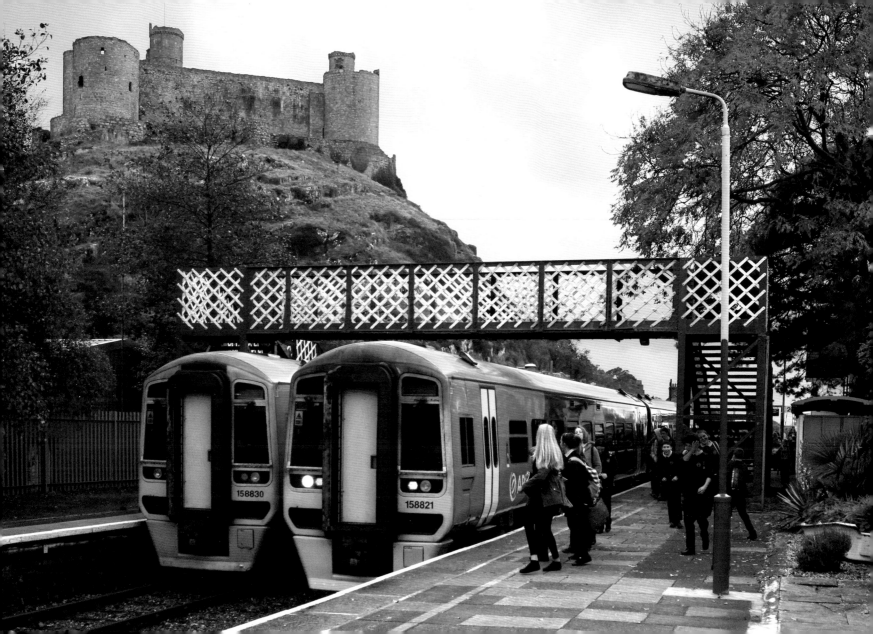

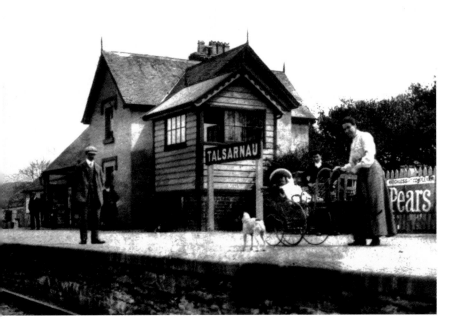

Left: Talsarnau

Heading north-eastwards in a dead-straight line, the railway runs across a level coastal area of breezy sand dunes, with mountains to the right of the line and the sea never far away to the left. Tygwyn Halt (99½ miles) was opened on 11 July 1927 and it is still in use, while Talsarnau, the next stop (100½ miles), was opened on 10 October 1867 as a simple, single-platform station with a small goods yard on the Up side – the yard being entered by means of a connection that was facing to the direction of Down trains. The 1938 Railway Clearing House *Handbook of Stations* reveals that the station was able to deal with a full range of goods traffic including coal, livestock, furniture, vehicles and general merchandise. The illustration shows the station building and signal box during the Edwardian period; the signal cabin, containing an eleven-lever frame, was closed in 1968 when Talsarnau became an unstaffed halt; goods traffic had ceased in 1964.

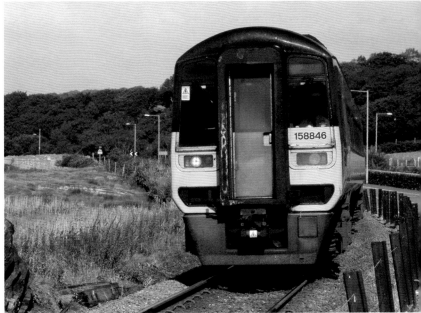

Right: Llandecwyn

Around 1 mile beyond Talsarnau, the line makes a 180-degree turn around the Traeth Bach or 'Little Beach' – an area of sand and marsh watered by the Afon Dwyryd. The river is crossed by a combined rail and road bridge at Pont Briwet, this 148-yard structure being of similar design to the much larger Barmouth Bridge. Llandecwyn Halt (101¾ miles), at the south end of the bridge, was opened by the GWR on 11 November 1935. The photograph is a close-up roadside view of Class 158 unit No. 158846, as it rounds the curve on the north side of the Pont Briwet bridge with the 9.42 a.m. Pwllheli to Machynlleth service on 6 August 2002. In November 2013, problems arose when the 154-year-old trestle bridge were reported to have 'moved', the movement being caused by piling work in connection with a replacement rail/road bridge that was being built alongside. This led to a cessation of rail services between Harlech and Pwllheli until 1 September 2014.

Minffordd

Turning south-westwards, trains reach Penrhyndeudraeth station
(102½ miles), which was opened on 2 September 1867 and is still
in operation, after which the line runs more or less parallel to the
1-foot-11½-inch gauge Ffestiniog Railway before the main line veers
north-westwards and passes beneath the narrow gauge line at Minffordd
(103½ miles). The Ffestiniog railway crosses the Cambrian line at right
angles on an arched bridge, and the two stations are linked by a sloping
path. In 1965, the Ffestiniog Railway took over local BR ticket sales and,
since that time, Minffordd has evolved as an interchange point between
the two systems – becoming in effect a single station with upper and
lower platforms.

When first opened, as a horse-worked line on 20 April 1836, the
Ffestiniog Railway had linked the slate quarries at Blaenau Ffestiniog
with the harbour at Porthmadog, from where slate was exported in
coastal vessels. In 1871, exchange sidings and a goods shed were opened
at Minffordd so that large quantities of slate could be moved out of the
area by rail, while the Cambrian passenger station was opened on
1 August 1872.

The upper view is looking north-westwards from the overbridge
on 19 October 2014; the high level narrow gauge line is visible in the
foreground, while the low-level standard gauge line can be seen to the
right. The Cambrian station, now unstaffed, has just one platform which
is situated on a tight curve and extends beneath the bridge carrying
the Ffestiniog Railway. The overgrown remains of the exchange sidings
can be seen to the left; the yard is used nowadays as a permanent way
depot. The lower picture is a view from c. 1920 of the Ffestiniog station,
looking south-westwards, with the station building to the left.

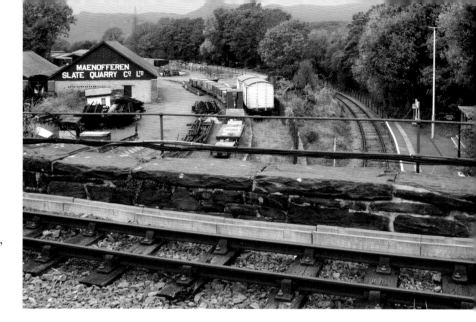

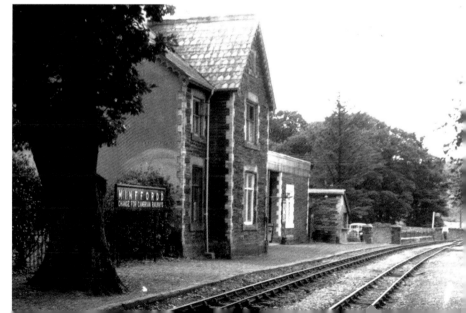

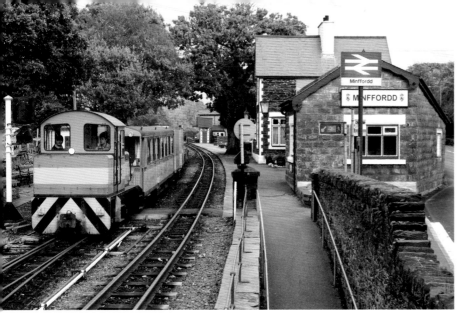

Above: Minffordd

A general view of the high-level FR platforms at Minffordd, looking north-eastwards on 19 October 2014 as the Ffestiniog Railway 0-6-0 diesel-hydraulic locomotive *Harlech Castle* pulls away from a the station with an engineering train heading for the nearby Minffordd Yard. *Harlech Castle* was built by Baguley-Drewry Ltd in 1983, and it had originally been destined for use in Mozambique. When it was delivered, it fouled the Ffestiniog loading gauge, and the engine could only be used in Minffordd Yard, but after being fitted with a reduced height cab it was employed on civil engineering duties along the whole FR line.

Below: Porthmadog – The Cob

On leaving Minffordd, the Cambrian and Ffestiniog routes run on more or less parallel alignments towards Porthmadog, where the narrow gauge line terminates in a relatively large station on the south side of the town, around half a mile from the main line station. Porthmadog was created around 1807–11 by William Alexander Madocks (1773–1828), who drained a large area of estuarial land in order to build a new slate exporting port. To facilitate this plan, he constructed the 'Cob' – an embankment that extends for almost a mile across the sandy expanse known as the Traeth Mawr. When completed in 1811, at a cost of £60,000, the Cob enabled around 3,040 acres to be reclaimed, in addition to over 1,000 acres that had already been reclaimed from the nearby Penmorfa Marsh. The Cob now carries the Ffestiniog Railway, as well as the main A487 road. The picture shows Ffestiniog Railway 0-4-4-0T No. 10 *Merddin Emrys* crossing the Cob with the 1.35 p.m. Porthmadog to Blaenau Ffestiniog service on 2 June 2012.

Opposite: Porthmadog – The Cambrian Station

Situated around 105¾ miles from Shrewsbury, the main line station was opened by the Aberystwyth & Welsh Coast Railway on 2 September 1867; the station was known as 'Portmadoc' for many years, but the name of the town was changed to 'Porthmadog' in 1974. The station is equipped with Up and Down platforms on either side of a crossing loop, the main station building being on the up side. The photograph shows Class 158 unit No. 158857 in Central Trains two-tone green livery at Porthmadog on 8 August 2002.

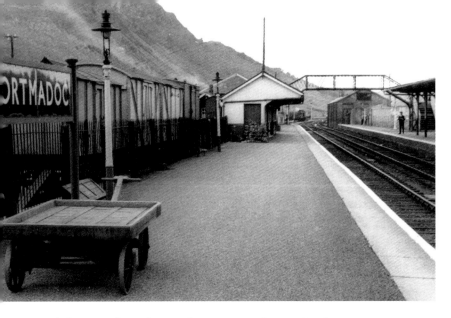

Right: Porthmadog – The Narrow Gauge Station

Situated at the north-western end of the Cob, the narrow gauge station at Porthmadog was opened by the Ffestiniog Railway on 6 January 1865, the name 'Porthmadog Harbour' being adopted around 1930. The photograph shows Ffestiniog Railway 0-4-0ST No. 4 *Palmerston* alongside the single platform, probably around 1930. The FR lost its regular passenger services in September 1939 and most of the line was closed to all traffic in August 1946 (although slate traffic was still being handled in and around Bleanau Ffestiniog). However, this historic line was reopened as a 'heritage' railway in 1955, initially between Porthmadog and Boston Lodge, although the route was subsequently reinstated in sections; Tan-y-Bwlch being reached by 1958, while Ddaullt served as a temporary northern terminus from 6 April 1968 until 25 June 1977, when the operational line was extended to a temporary station near Tanygrisiau. Tanygrisiau station was reopened on 24 June 1978, and the railway was finally reopened throughout its length from Porthmadog to Bleanau Ffestiniog on 25 May 1982.

Left: Porthmadog – The Cambrian Station

A view of the Down platform, looking north towards Pwllheli in 1963. The goods yard, which is visible to the left, contained a hip-roofed goods shed, together with the usual coal wharves, a weigh house and a 6-ton yard crane. The cattle-loading pens were situated beyond the level crossing on the Up side, while the station was signalled from a gable-roofed signal cabin with a thirty-eight-lever frame; the cabin was taken out of use in October 1988 in connection with the introduction of the RETB signalling scheme. The facilities at Porthmadog also included a two-road engine shed which, in 1948, had an allocation of nine locomotives, comprising four Dean Goods 0-6-0s, two 3251 Class 0-6-0s, two 45XX Class 2-6-2Ts and former Cambrian Railways 0-6-0 No. 894. The footbridge and the Down side station building have now been demolished.

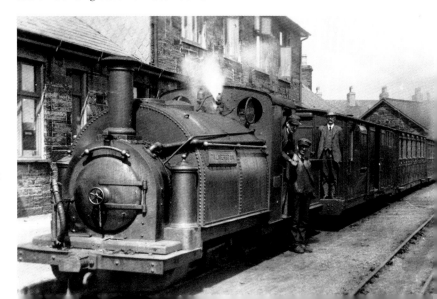

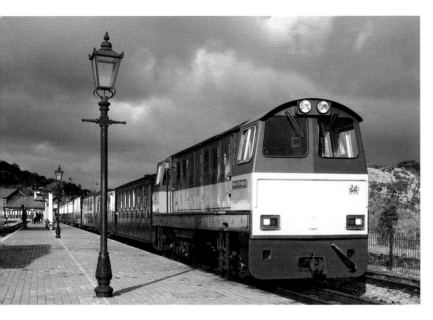

Right: Porthmadog – The Narrow Gauge Station

Contrasting narrow gauge motive power at Porthmadog Harbour station on 21 October 2014. On the right, former South African NGG16 Class Beyer Garratt locomotive No. 143 has just arrived with the 2.15 p.m. Welsh Highland Railway service from Caernarfon, while on the left double-boilered Ffestiniog Railway Fairlie 0-4-4-0T No. 12 *David Lloyd George* has just moved forward in readiness to shunt the empty stock off the 3.05 p.m. train from Blaenau Ffestiniog. This picture provides a good view of the new £1¼ million double-sided platform, which allows Ffestiniog and Welsh Highland trains to occupy the station at the same time. Other WHR locomotives include repatriated NGG16 Class Garratts Nos 87, 109, 138 and 140, together with NG15 Class 2-8-2s Nos 133 and 134, and a single-cab 'Funkey' diesel named *Castell Caernarfon*. The photograph illustrates the different loading gauges of the FR and Welsh Highland railways – the WHR locomotives being considerably larger than their Ffestiniog counterparts.

Left: Porthmadog – The Welsh Highland Railway

In 1877, an undertaking known as 'The North Wales Narrow Gauge Railway' was opened between Dinas and Rhyd-Ddh, near the summit of the Nant-y-Bettws Pass. After many vicissitude, this 1 foot 11½ inch gauge line and the much earlier Croesor Tramway were incorporated into the route of 'The Welsh Highland Railway', which was opened throughout between Porthmadog and Dinas in 1922/23. With little freight to sustain it, the WHR relied heavily on tourist traffic, but the hoped for tourists did not arrive in sufficient numbers, and the line was closed to all traffic in 1937. A preservation group was started in 1961, and after an extremely protracted gestation period the line was reopened in stages between 1997 and 2011. In its present-day form, the Welsh Highland Railway runs from Porthmadog Harbour to Caernarfon, a distance of 25 miles. The picture shows the Ffestiniog Railway's rebuilt 'Funkey' diesel *Vale of Ffestiniog* at Porthmadog on 21 October 2014.

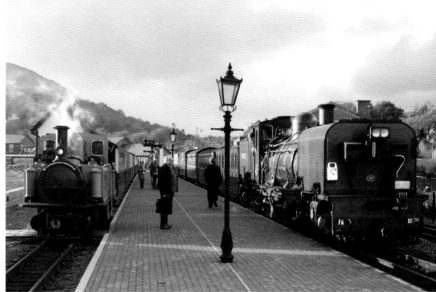

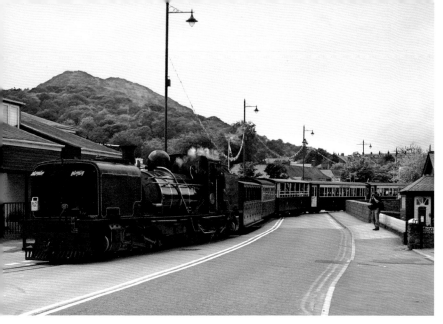

Porthmadog – The Welsh Highland Railway

Left: Ex South African NGG16 Class Garratt No. 87 weaves across Porthmadog High Street, as it arrives at Porthmadog Harbour station with the 12.55 p.m. service from Caernarfon on 2 June 2012. As well as the impressive scenery further up the line, this elongated level crossing, with the track actually running along the road for a short distance, is one of the highlights of the Welsh Highland route.

Below left: Ffestiniog Railway 0-4-0ST Blanche takes water at Ddualt on 9 July 1973; this locomotive was built by the Hunslet Engine Co. in 1893 for service on the Penrhyn Railway.

Below right: Ffestiniog Railway 0-4-4-0T Fairlie locomotive No. 12 *David Lloyd George* arrives at Porthmadog Harbour station after crossing the Cob on 12 October 2014. The locomotive will shortly be working the 10.10 a.m. service to Blaenau Ffestiniog.

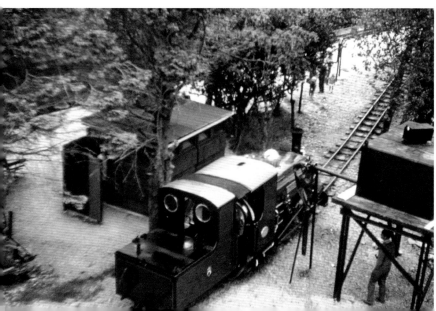

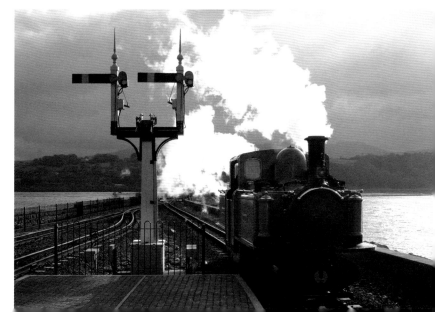

Left: Porthmadog – Some Tickets

A selection of tickets from the Porthmadog area, including two British Railways singles from Penryhndeudraeth, and Ffestiniog Railway Edmondsons from Porthmadog, Penryhn, Dduallt and Tany Grisiau. The Ffestiniog Railway retained its old-fashioned Victorian-style colour-coded tickets for many years; first and third-class singles were printed on white and green cards respectively, while return tickets were dual-coloured – first-class returns being white and yellow (No. 218), while third-class returns were green and buff (No. 1772). Dog tickets were brick red (No. 684) and 'Quarryman' tickets were pale yellow with vertical red stripes (No. 560).

Right: Black Rock Halt

From Porthmadog, the Cambrian route runs first west and then south-westwards as it heads towards the coast – Black Rock (109¼ miles), is the next stopping place, being virtually on the seashore. Opened on 9 July 1923 to serve the nearby Black Rock Beach, this unstaffed halt consisted of a sleeper-built platform on the down side, together with a simple waiting shed, as shown in the accompanying photograph. The wooden platform was declared unsafe and closed in August 1976, pending completion of the necessary closure procedures.

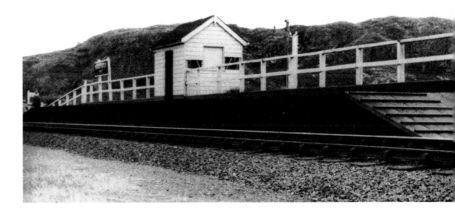

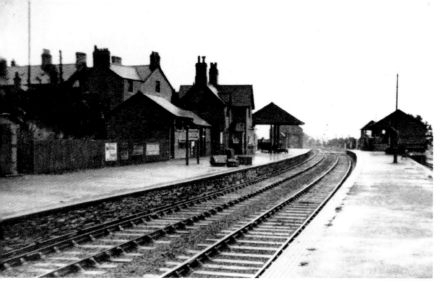

Left: Criccieth

Now heading due west, trains soon reach Criccieth (110¾ miles), the birthplace of the Liberal politician, war leader and statesman David Lloyd George (1863–1945). Opened by the Aberystwyth & Welsh Coast Railway on 2 September 1867, Criccieth station was formerly a passing place on the single line, but its crossing loop was taken out of use in 1977, and all trains now use the former Up platform. The station building was another 'Victorian house' design, incorporating domestic accommodation for the stationmaster and his family, while the down platform featured a short bay at its west end. The standard Cambrian Railways signal cabin was sited at the east end of the platform in convenient proximity to the level crossing. The bay platform was, for several years, the parking place for a camping coach.

Prior to rationalisation, the track layout had incorporated a goods yard on the Up side, the main goods siding being linked to the Down loop by means of a trailing connection; this siding served the goods shed and the cattle-loading pens, while a second siding extended eastwards from the east end of the Up loop, and these two sidings continued eastwards for a considerable distance before terminating just short of a level crossing that carried a minor road across the line. Two further goods sidings extended westwards, one of these being entered by means of a trailing connection from the Up loop, while the other was arranged as a 'kick-back' spur from the goods shed road. Goods facilities were withdrawn in 1964. The upper photograph is from an old postcard dating from around 1925, while the lower view shows the western extremity of the platforms, looking west towards Pwllheli around 1963.

Opposite: Criccieth

Despite the removal of its crossing loop and the addition of various modern signs, Criccieth station retains plenty of period character, as shown in this recent photograph, which shows Class 158 unit No. 158821 arriving exactly on time (note the train indicator) with the 3.37 p.m. Pwllheli to Machynlleth Arriva Trains Wales service on 20 October 2014.

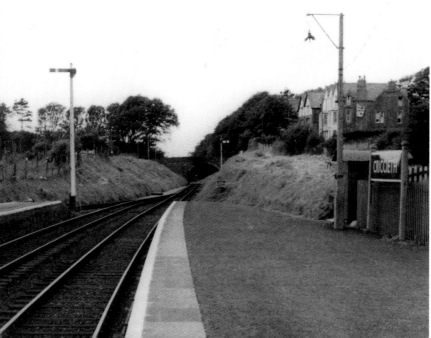

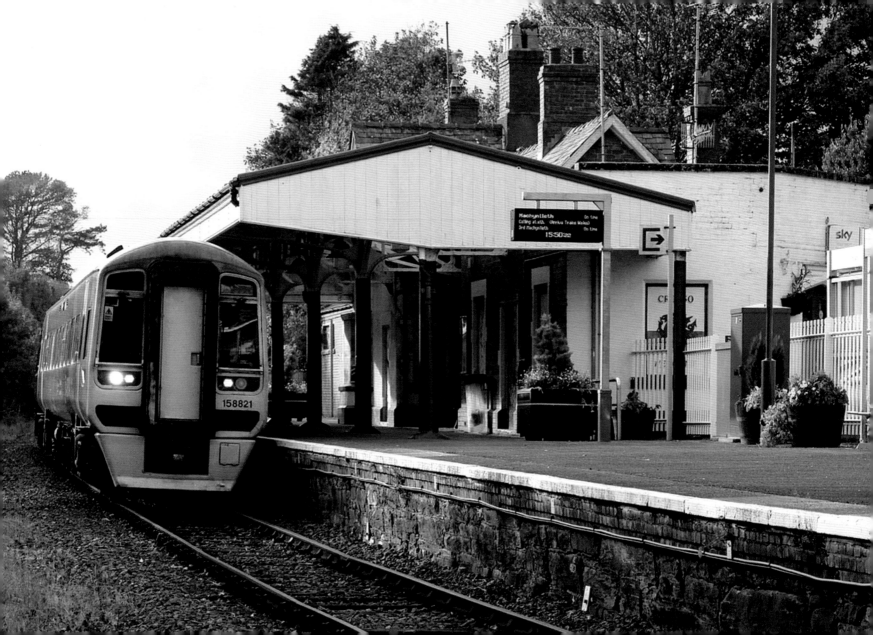

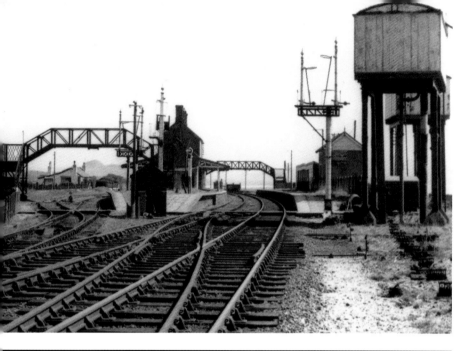

Afon Wen

Coasting downhill from Criccieth, Down workings run through a tract of pleasant pastureland before reaching the seashore on the approaches to Afon Wen (114¼ miles). Opened on 2 September 1867, Afon Wen became a junction on 2 September 1867 when the Carnarvonshire Railway was opened between Caernarfon and Afon Wen. In 1870, a connection was established between the Carnarvonshire line and the Bangor & Carnarvon Railway at Caernarfon, and trains were, thereafter, able to run through to Bangor on the Chester & Holyhead main line. There were, in general, around eight or nine trains each way between Afon Wen and Bangor, these services being worked by the London & North Western Railway, which absorbed the Bangor & Carnarvon Railway in 1867. In later years, some trains from the Bangor line reversed at Afon Wen in order to reach the Butlin's holiday camp station at nearby Penychain.

The infrastructure at Afon Wen consisted of Up and Down platforms for Cambrian services and an additional platform face for branch trains – the Up platform being an island with tracks on either side. The main station building was on the island platform, and it boasted canopies on both sides. Afon Wen was primarily an interchange point for passengers, but the 1938 Railway Clearing House *Handbook of Stations* reveals that the station could also deal with goods traffic – although in practice very little freight traffic was ever handled at this remote location. The station was closed with effect from 7 December 1964, when passenger services were withdrawn from the line to Caernarfon. Little now remains to mark the site of this rural junction station. The upper view shows Afon Wen around 1963, while the lower picture depicts an assortment of tickets from Afon Wen, Pwllheli and other stations at the northern extremity of the Cambrian Coast route.

Pwllheli – Butlin's Holiday Camp

At Penychain (115¼ miles), a short distance beyond, trains run through the site of a former Butlin's holiday camp, which was served by a spacious modern station that had first been opened as a halt on 31 July 1933. The holiday camp was under construction at the start of the Second World War, and the unfinished site was taken over by the Admiralty during the ensuing conflict, when it became a naval training centre known as HMS *Glendower*. The camp reverted to civilian use after the war, and in May 1947 an enlarged station was opened to serve 'Butlin's Pwllheli'. The line was doubled from Afon Wen to Penychain, and lengthy Up and Down platforms were provided, with spacious stone buildings on both sides. The platforms were signalled for bi-directional working, but when traffic was light all trains normally used the Up platform.

The holiday camp suffered a huge fire on the night of 9/10 August 1973 when the Gaiety Theatre complex was utterly destroyed. By the 1970s, most campers were arriving at Pwllheli by car, and the station declined in importance, while in 1998 the camp was closed and the site then became a Haven holiday park, with the emphasis on static caravans. Although the entertainment buildings were rebuilt after the 1973 fire, most of the former Butlin's infrastructure has now been removed.

The photograph shows the 12.09 a.m. Birmingham International to Pwllheli service accelerating away from Penychain on 20 October 2014 after briefly slowing down in the vain hope that there might have been some passengers. The belt of trees behind the station building hides the obtrusive caravans from view, while the Down line has been lifted, and all trains now use the former Up platform. The Down side station building has been demolished, and the Up side building has been reduced in size – the present building being merely a large waiting shelter.

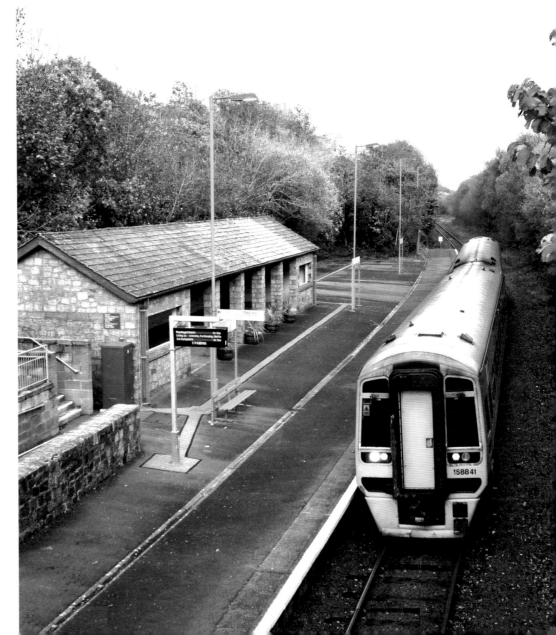

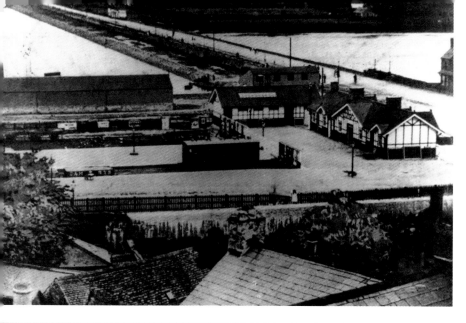

Railway Station and Harbour, Pwllheli

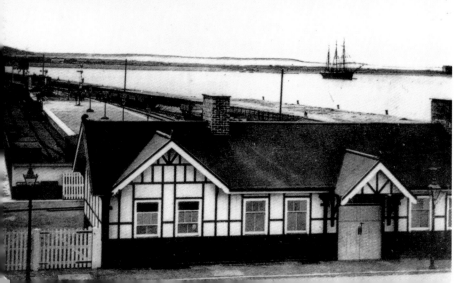

Pwllheli

With their destination now close at hand, trains continue westwards along more or less level alignments to Abererch (116¾ miles), another simple halt, which was opened by the GWR in July 1884. Beyond, the route runs parallel to the River Erch, and having passed the site of Pwllheli's original 1867 station, trains reach the end of their long and leisurely journey in the present-day Pwllheli station, which is 118¾ miles from Shrewsbury and 132¾ miles from Whitchurch. The terminus is, in fact, of relatively recent construction, having been opened on 19 July 1909 to replace the earlier station.

The new station was built on land reclaimed during the construction of Pwllheli's inner harbour, and it consisted of a spacious, double-sided platform, with a carriage dock on the north side. The two platforms were both equipped with run-round loops, and the main station building was sited at right angles to the terminal buffer stops. There were no goods-handling facilities at the new station – the goods yard and carriage sidings and engine shed being sited at the old station.

The upper photograph is a panoramic view of the new station at the time of its completion around 1909. The inner harbour can be seen to the south of the station, while the station building is visible to the right. The latter structure was of timber-framed construction with a low-pitched gable roof, red-brick chimney stacks and curious scroll finials. The lower view, also dating from around 1909, shows the north end of the terminal building in greater detail. A glazed roof was subsequently erected over the spacious concourse, together with a length of canopy at the west end of the platform.

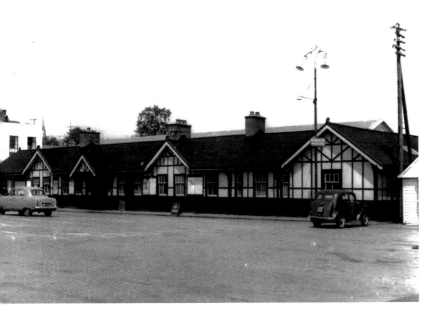

Left: **Pwllheli**
A later photograph of the wooden station building, taken during the early 1960s. The building has obviously been extended at both ends, a new portion having been added at the north end, while the southern end of the main building has been joined to the cross wing to create an L-shaped structure. The double doors towards the left of the building gave access to the ticket office.

Right: **Pwllheli**
A platform view, looking eastwards around 1961. Pwllheli station has remained in operation as part of the national rail system, but the station facilities have been considerably reduced, and only one platform remains in use, together with a run-round loop and a stabling siding. The south side of the station site is now occupied by a supermarket, but part of the canopy has survived, and the station concourse retains much of its traditional 'Victorian' atmosphere. Although the terminal building is a relatively modern structure, it is now a Grade II listed building, having been listed in 1989 as 'a rare example of a seaside vernacular style railway station'. The main station building is now a café.

CAMBRIAN RAILWAYS.

Summer Tours in North Wales.

Bathing, Boating, Fishing (Sea, River, & Lake,) Coaching, Mountaineering.

1st, 2nd, and 3rd Class Tourist Tickets,

Available for Two Calendar Months, renewable up to 31st December, are issued from 1st May to 31st October, at all the principal Stations in England, to

Aberystwith, Aberdovey, Towyn, Dolgelley, Barmouth, Criccieth, Borth, Harlech, Portmadoc, and Pwllheli.

The Scenery traversed by and adjacent to the Cambrian Railways is of an exceedingly varied and beautiful description, and the coast of Cardigan Bay, to which the line affords the most convenient access, offers great advantages for sea-bathing in the long reaches of firm, safe, and sandy beach, with which it abounds, and in its pure and bracing air. The mountain ranges of SNOWDON, CADER IDRIS, and PLYNLIMON, with their Rivers and Lakes, are also readily accessible from the various Watering-places, thus placing within the reach of visitors a delightful combination of the natural beauties of sea and land.

Arrangements are made during the Summer Months for the conveyance of Visitors by Coach to and from places of interest in the vicinity of the Line at reduced charges, by which means, and also by the Festiniog, Talyllyn, and Corris miniature-gauge Railways, whose termini are on the Cambrian system, the following amongst other places can easily be visited by daily Excursions:—

Snowdon, Beddgelert, Tan-y-bwlch, Festiniog Slate Quarries, Cwmbychan Lake, Mawddach Estuary, Precipice Walk and Torrent Walk, (Dolgelley), Talyllyn Lake, Corris, Rheidol Lake, Devil's Bridge, &c.

19

Pwllheli – The Llanbedrog Tramway

Above: It is interesting to note that Pwllheli was not always the end of the line, for in 1894 a 3-foot-6-inch gauge tramway was laid along the sand dunes to quarries at Llanbedrog, aound 4 miles to the west. Passenger services began in 1896, when an extension was laid between the original terminus and Pwllheli Post Office, near the Cambrian Railways station. Passengers were carried in horse-drawn vehicles, most of these being 'toast-rack' type tramcars. The tramway 'main line' was linked to the 1909 station by a frequent shuttle service, which was worked independently of the Llanbedrog 'main line', Sadly, the tramway was abandoned as a result of severe storm damage in October 1927, and the remaining track was lifted in the following year. The photograph provides a glimpse of the tramway terminus at West End – a tramcar being discernible beyond the cluster of bathing huts.

Left: A Victorian handbill advertising first, second and third-class summer tourist tickets between English stations and destinations on the Cambrian system.